# ILLUSTRATION IN THE THIRD DIMENSION

Library of Congress Cataloging in Publication Data

Society of Illustrators, New York.
Illustration in the third dimension.

(Library of American illustration) (Visual communica-
tion books)
1. Art, American. 2. Art, Modern—20th century—
United States. 3. Artists—United States. I. Title.
II. Series.

N6512.S63 1977     709'.73     77-7316

ISBN 0-8038-3399-7

Published simultaneously in Canada by
Saunders of Toronto, Ltd., Don Mills, Ontario

Printed in the United States of America

Society of Illustrators
Library of American Illustration

# ILLUSTRATION IN THE THIRD DIMENSION

## The Artist Turned Craftsman

*VISUAL COMMUNICATION BOOKS*

Hastings House, Publishers
10 East 40th Street, New York 10016

For The Society of Illustrators

Howard Munce, Editor

Robert Geissmann, Designer

Gerald McConnell, Co-ordinator

# Contents

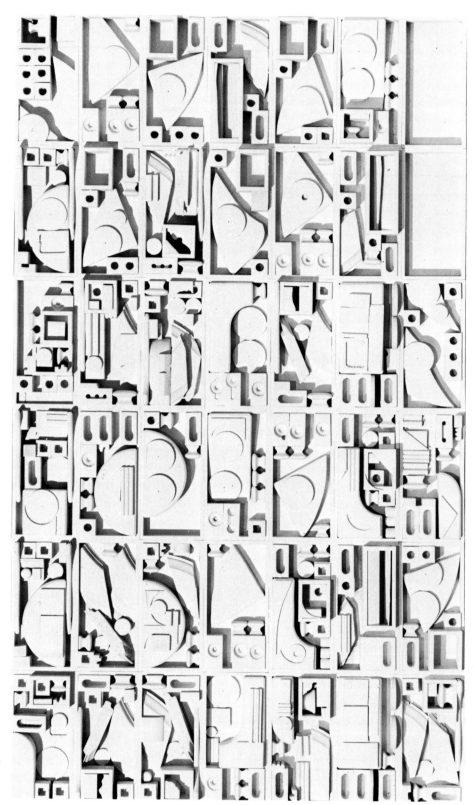

Louise Nevelson
**Dawn's Landscape XXIII,** 1975.
White painted wood, 50 x 30 x 2½."
Reprinted by permission of
The Pace Gallery, New York City.

Alexander Calder
**The Horse,** 1928.
Walnut, 15½ x 34¾."
Collection, The Museum of Modern
Art, New York City. Acquired
through the Lillie P. Bliss Bequest.

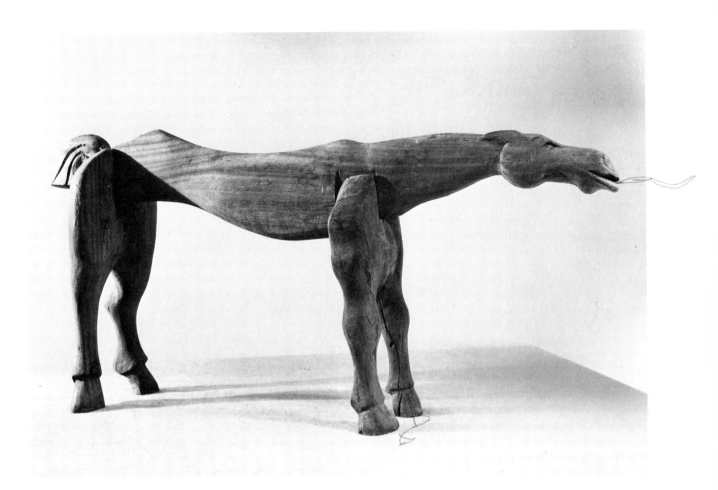

# Introduction

Some time back, Man finally yanked his hind foot free of the primeval ooze and went on to other things. More recently, the illustrator has begun to do somewhat the same thing: he has freed himself from the fetters of the flat surface, hooked a tool box to his taboret, and taken off on an exciting spree of rounded, pounded, folded, moulded, glued, screwed, nailed, carved, cast, bent, soldered and welded creations.

In doing so, he's employed every imaginable stuff: wood, wire, tin, plaster, epoxy, iron, felt, rocks, thread, sand, beans, buttons and beer caps. The found object has been re-found with a vengeance. Attics, junk shops, dumps and bureau drawers are continually combed for their yield of usable things.

The artists this book deals with are as familiar with the products of Black & Decker as they are with the output of Winsor-Newton.

Out smock! In overall!

It has taken the illustrator a long time to get around to this manner of working.

The inspiration to do so beckoned long ago. There were Kurt Schwitters' collages of bits and pieces of printed remnants. There was the explosion of Dadaism. There was Duchamp, Dove, Sabo, Arp, Pevsner and Ernst. There was the Bauhaus with its preoccupation with materials. There was the early miniature circus by Calder. And there were all the other hints of collage and assemblage from Cubism's heyday.

There was always Origami, the folded paper fantasies of the ever clever Japanese. But nobody noticed. Most were too busy bent over their Whatman Boards rendering automobiles, refrigerators and boy meeting girl in an endless variation of the clinch.

The closest the illustrator came to the third dimen-

sion was to trowel a raised texture onto his gesso panel.

Then suddenly a lot of things happened fast. There was an eruption in the magazine and advertising fields. Books folded. Markets dried up. The kicky agency emerged and with it the bearded bell-bottomed art director and the bra-less writer. They overturned the Brooks Brothers' world in an orgy of "creativity." The photograph prevailed and television mushroomed.

All these things helped seal the fate of the imitative pedestrian illustrator. Simultaneously, a new batch of inventive kids pouring out of art schools and a small group of established pros began to be aware of what was going on in the galleries.

There were Steinberg's inspired insanities—there was Jasper Johns with his bronze beer cans, light bulbs and sectional boxes, Louise Nevelson with her black constructions of found furniture and manufactured wood parts—Robert Rauschenburg making use of automobile tires, stuffed goats and burned mattresses. Siegal with his plaster casts of people in actual collected environments. Marisol with her milled wood sculpture—painted on and drawn upon. Oldenburg with his limp lampoon of our society. And the beautiful boxes of Joseph Cornell. And somewhere in the midst of these titillating influences came the fantastic show of Picasso's life time sculpture. Its six weeks' showing at the Museum of Modern Art in New York in 1965 was a stunning event that radiated shock waves in all directions.

The 1958 Society of Illustrators Annual contained only one piece of dimensional work—a mild little decorative collage. Since then approximately 300 pieces have been published in the Annual—scores more were submitted.

This book contains much of the best of the 16 Annuals so far published plus a goodly number newly published and unpublished work. Enclosed are the efforts of some very able imaginative people.

The emergence of this new exciting way to interpret graphic problems has been welcomed by art directors and editors who are ever on the prowl for fresh approaches to fill the maws of a business that devours fashions and trends at a frightening rate.

Many of the enclosed 27 talents are supplying a goodly portion of what's being used at this writing. It's all just beginning, really.

*Howard Munce*

Claes Oldenberg. **Giant Toothpaste Tube**, 1964.

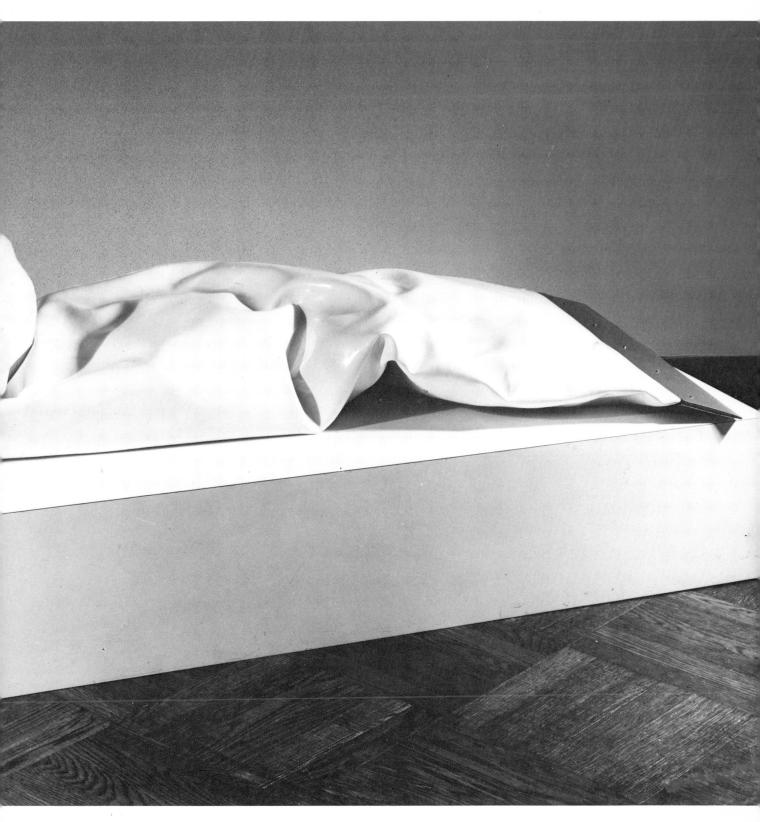

Vinyl over canvas filled with kapok, 25½ x 66 x 17." Collection of Richard Tucker, Ft. Worth, Texas.     9

Jasper Johns
**Light Bulb,** 1968-70.
Sculpmetal, wire & polyvinyl
chloride, dimensions variable.
Collection of Mark Lancaster.

Kurt Schwitters
**Picture with Light Center** *(Bild mit heller Mitte),* 1919.
Collage of paper with oil on
cardboard, 33¼ x 25⅞."
Collection, The Museum of Modern
Art, New York City.

Robert Rauschenberg (page 12)
**Coexistence,** 1961.
Combine painting, 60 x 42."
By permission of Leo Castelli
Gallery, New York City.

Alexander Calder (page 13)
**Lobster Trap and Fish Tail,** 1939.
Hanging mobile: painted steel wire
and sheet aluminum, about 8'6" x 9'6."
Collection, The Museum of Modern Art,
New York City.

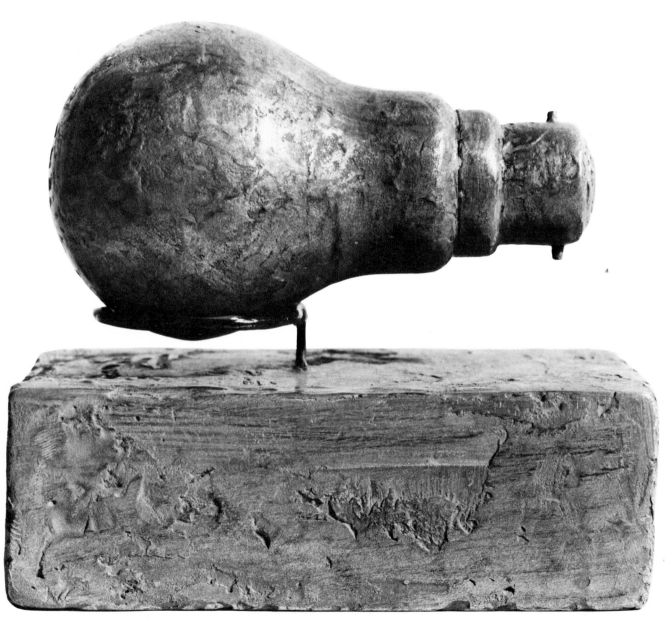

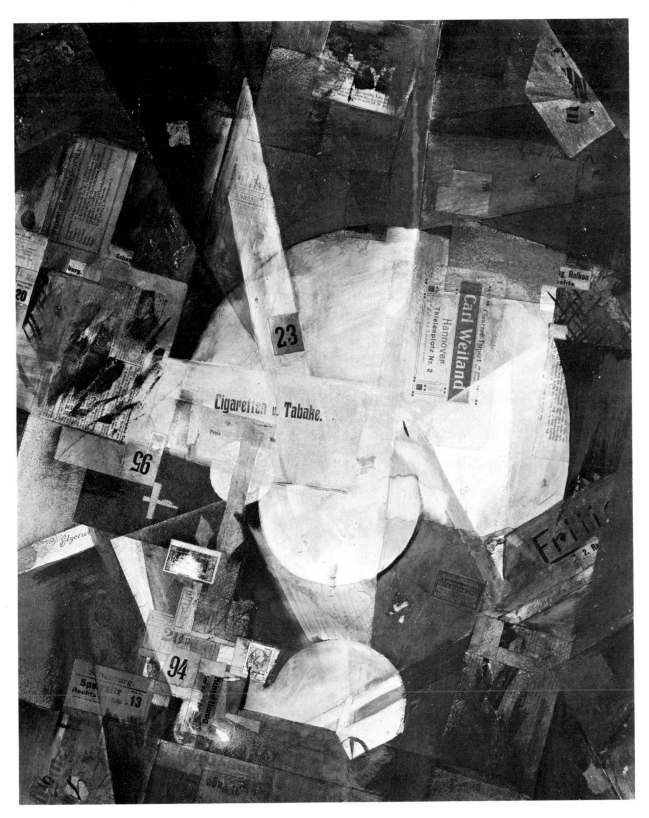

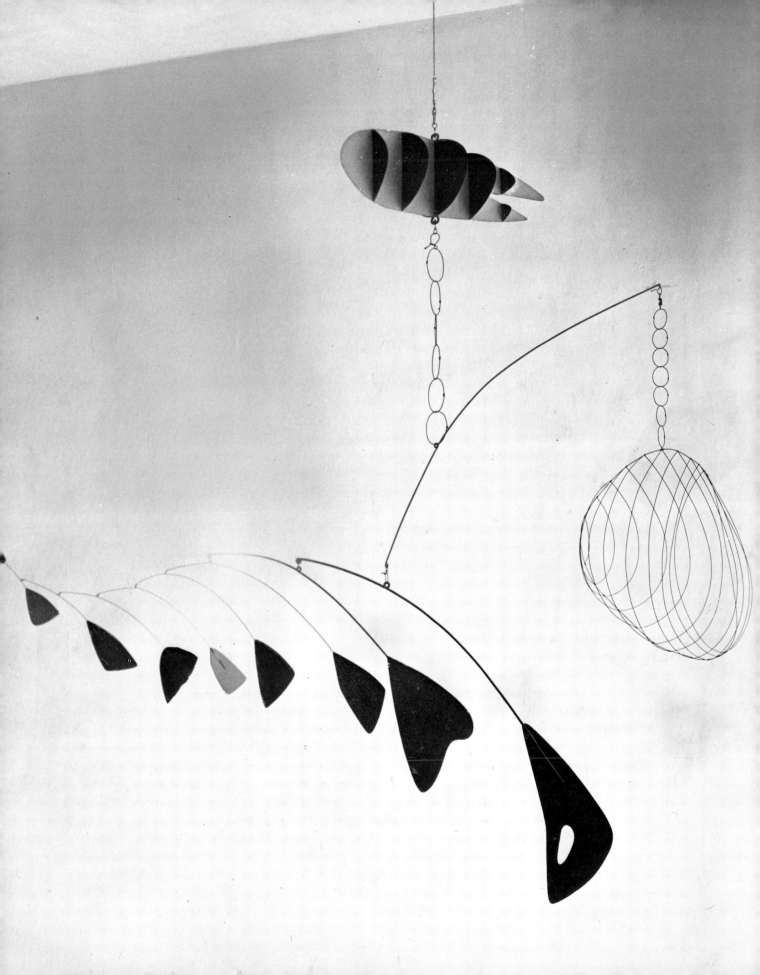

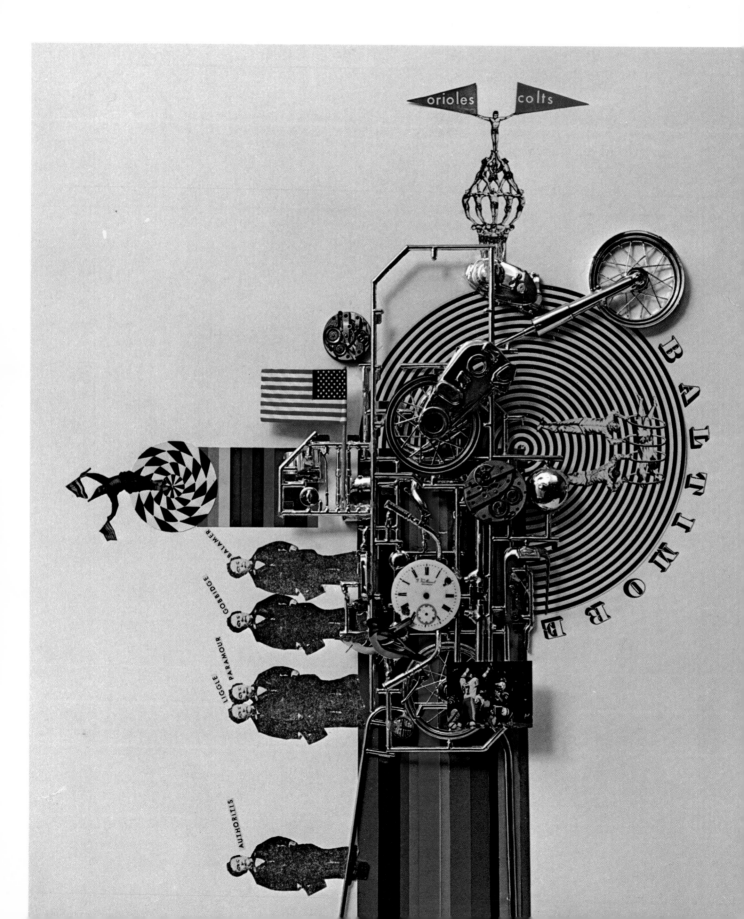

# Fred Otnes

This is one (at left) of a series of 12 illustrations I did for an ABC television booklet entitled "Commentary" consisting of six each of Harry Reasoner's and Howard K. Smith's essays from their evening telecast.

This was Howard K. Smith's tongue in cheek commentary on how everything great happens in Baltimore as opposed to Washington—"the humiliating thing about living in the nation's capital is...our next-door neighbor is Baltimore. Baltimore always does what we dream of, but never do—it wins." He was referring, of course, to their pennant and Super Bowl victories and went on to discuss their speech patterns and city history in a mock envious way.

I feel that the mood, technique, and general direction of an illustration should reflect the point of view of the text and that the artist should not impose "his style" on the solution. In this particular piece I needed a way to visually translate the idea of Baltimore's super victories, something that would pop up from the bottom of the page, that would be all shiny and glorious. I recalled the fantastic pin ball machine in William Saroyan's "The Time of Your Life" when in the final act a character in the play achieves the ultimate triumph over the machine and it lights up, cannons fire, flags wave and music plays.

The assemblage machine I devised, using that concept, of course did not have to actually function. The wheels and gears were made from the chrome covered plastic parts from the toy kits available in hobby shops. Watch parts and op circles contribute to the mechanical look and the stripes give direction and color. The repeated figure image gives movement and in a design sense the illusion of the fourth dimension (time).

I photographed the finished art myself using a 4 x 5 camera. The simplest sort of one source light seems to best produce a very soft shadow that is enough to accentuate the three dimensional quality.

15

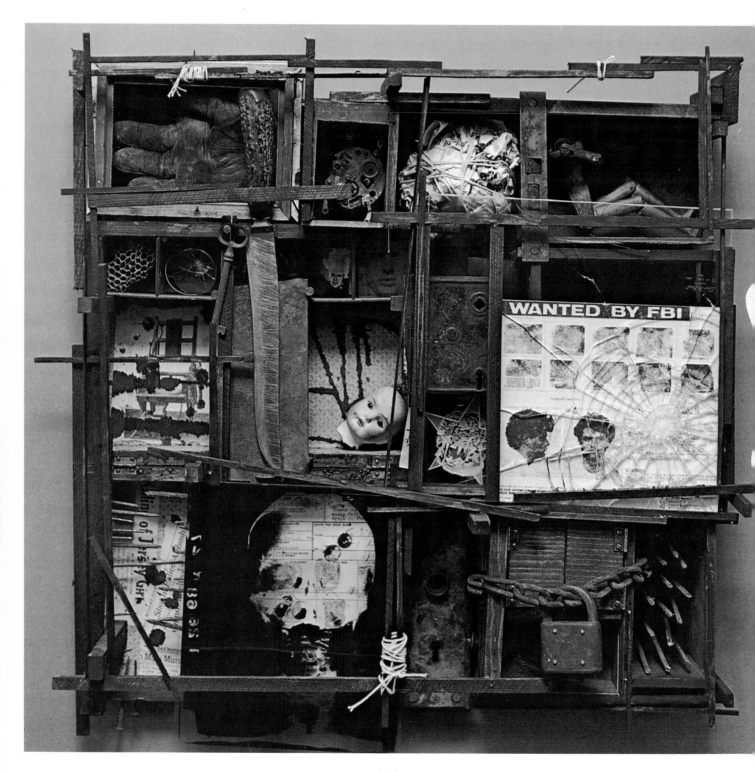

16

A stark construction for a Medical Times cover on the subject of treatable violence.

**Fred Otnes**

*Born / Junction City, Kansas*

*Studied / Art Institute of Chicago*

*Illustrated for / Post, Life, Look, Seventeen, Lithopinion, Fortune, Atlantic Monthly, Intellectual Digest, New American Review*

*Awards and Honors / Over 80 awards — AIGA, Art Directors Clubs, C-A, Society of Illustrators, etc.*

*Art Affiliation / Society of Illustrators*

*Teaches / Graduate students, Art Center School in my studio (currently)*

17

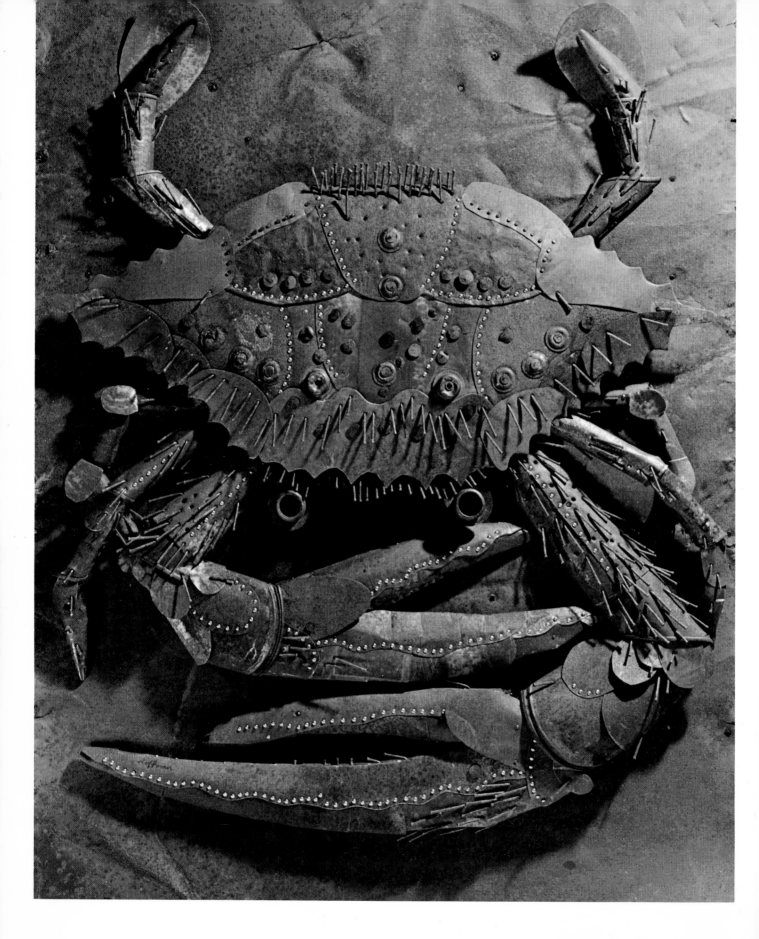

# Eugene Hoffman

I enjoy working with junk and discarded materials for several very good reasons. First, because of their natural beauty which comes with age and weather. And secondly, because there will always be an endless supply. Also I can kill the proverbial two-birds-with-one-stone in that my exploration for caches of old tin cans often times lead me to the high country of Colorado's Rocky Mountains: crystal clear air, brilliant sunshine and quietude are a few of the fringe benefits of looking for junk in Colorado's old mining towns. My wife and I regularly hop into our ancient Jeep and head for the mountains. My workshop many times is the hood of the Jeep. I carry metal shears, pliers, a hammer and nails and knife. They become my pallette and brushes.

All I need to produce an assemblage, I can readily find by the side of an old mining trail. For example, for the background of a picture or illustration, a sheet of rusted metal from a shack that has long since been leveled by wind and tons of snow throughout scores of high country winters—an old piece of plywood to nail to, a few scraps of wood for an armature, and I have basically all my needs. I often work sitting on the hood carving a rough form on which I will nail pieces of old metal cut from multi-colored, multi-textured, larger pieces of metal, cans, etc. Some of the assemblages are done on commission but there are some that are for the sheer joy of it. Assemblage is just one facet of the styles or techniques I employ. It is, however, the most rewarding in that I feel I have in some very small way helped in using *trash* to create a pleasant image which, after all, is what I do—create images.

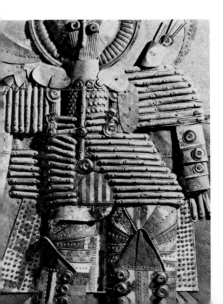

**Eugene Hoffman**
*Born / Gettysburg, Pennsylvania*
*Studied / Arizona State (at Flagstaff)*
*Illustrated for / Houghton-Mifflin,
Boston retail accounts, Design posters
for ski areas, Public Service Co. of
Colorado, Dixon Paper Co.,
Alpine Design Co.*
*Exhibited / Los Angeles, San Francisco,
New York, Denver, Zurich, Aspen*
*Awards and Honors / 50 Gold Medals,
Silver, Awards of Excellence shows
throughout the United States*
*Art Affiliation / Ad Club of Denver*

19

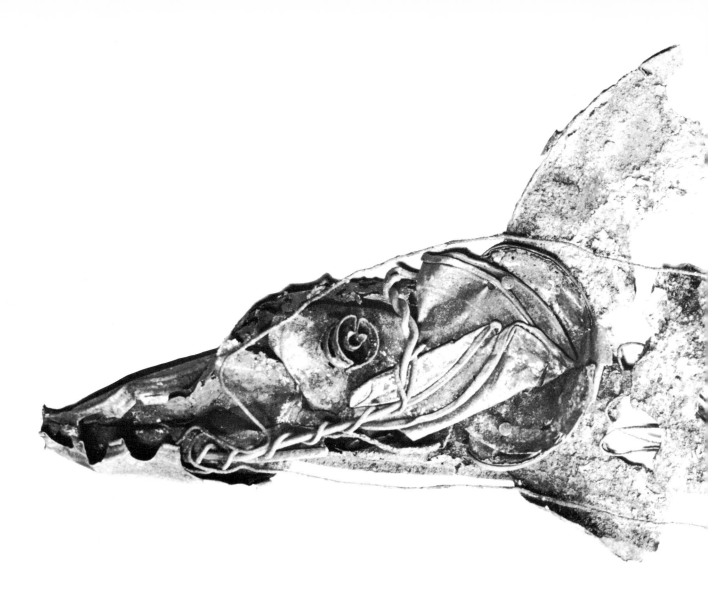

# George Porter

A few years ago a pile of rusted, twisted, discarded junk lay in the corner of my studio. I really don't know why I had collected it. Perhaps it was my great interest in abstract forms and the unusual colors I saw in the old scrap—or possibly it was the calligraphy suggested in the antique wire baskets, springs and twisted wire. Whatever—the metals excited me.

At the time, I had labored for weeks over three paintings that seemed to be going nowhere. In my frustration I turned to this weird collection and lost myself with a hammer and pliers for the rest of the day. It was completely satisfying! For almost immediately, intriguing combinations developed. Large chunks were laced with intricate patterns of wires and odd pieces of almost black geometric patterns. Masks fell into place

20

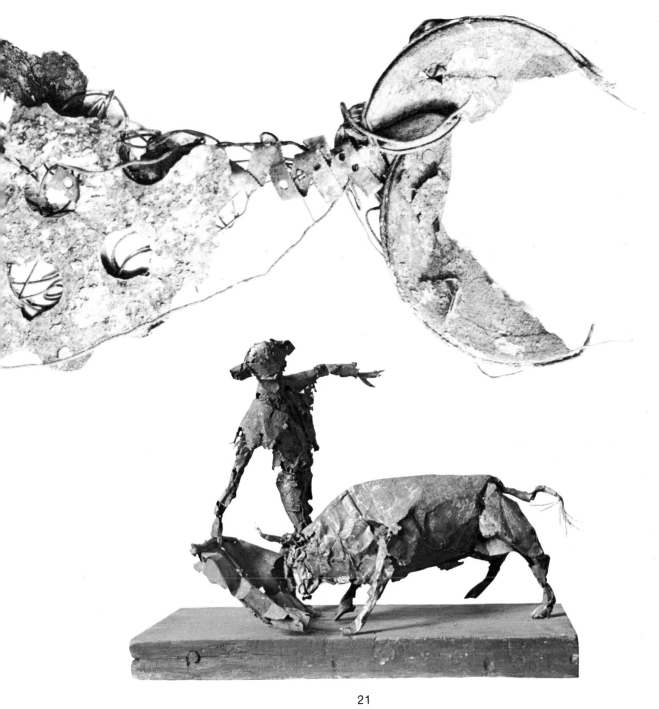

21

almost without trying. I could see animal forms that could be pushed in any direction. There was suddenly no doubt about why this "treasure" had remained under foot.

Three dimensional art had never seriously occurred to me. Carving was a lot of fun but so painstaking that I would soon lose whatever creative urge I had. Clay was a total disaster. The results were unexciting. But here surrounded by all the various shapes, patterns and linear ideas, things developed so fast that my biggest problem was keeping the pieces under control so that a specific image could take shape.

My first efforts were mounted on white plywood. One of these, a donkey, developed very fast; I did a bit of research on the general characteristics of the animal. I found a rough sketch in heavy black pencil was necessary to solve the desired action and character. The first pieces chosen described part of the skeleton and rib cage. I nailed them down permanently in the center of the plywood. The rib cage was a cushion spring that was pounded and twisted to the desired shape. The figure developed from the skeletal form out. From the heap an individual piece would almost dictate the part it would play in the construction and character of the animal. To temporarily secure the construction as it developed, I used wires, more nails and cold solder (tube, preferably aluminum). Wire, all sizes and lengths proved to be the catalyst. For it maintained the action, strength and flow of the figure. The metals produced surprises and happy accidents that one could never conceive with oil paint. This was no ordinary donkey that emerged. He was the all-time ass!

**George Porter**

*Born / Perry, Florida*

*Studied / Ringling School of Art, Sarasota Florida, Brooklyn Museum Art School, studied with Thomas Fogarty Sr., Franklin Booth, Reuben Tam*

*Illustrated for / Good Housekeeping, McCalls, Saturday Evening Post, Woman's Day, Boy's Life, Parents, Random House, Viking and leading advertising agencies, New York*

*Exhibited / New York City, Boston, Univ. of Oklahoma, Far East, Greenwich, Ct., Mt. Kisco, Pleasantville and Katonah, N.Y.*

*Awards and Honors / Society of Illustrators, Art Directors Club, Local and National shows*

*Art Affiliation / Society of Illustrators*

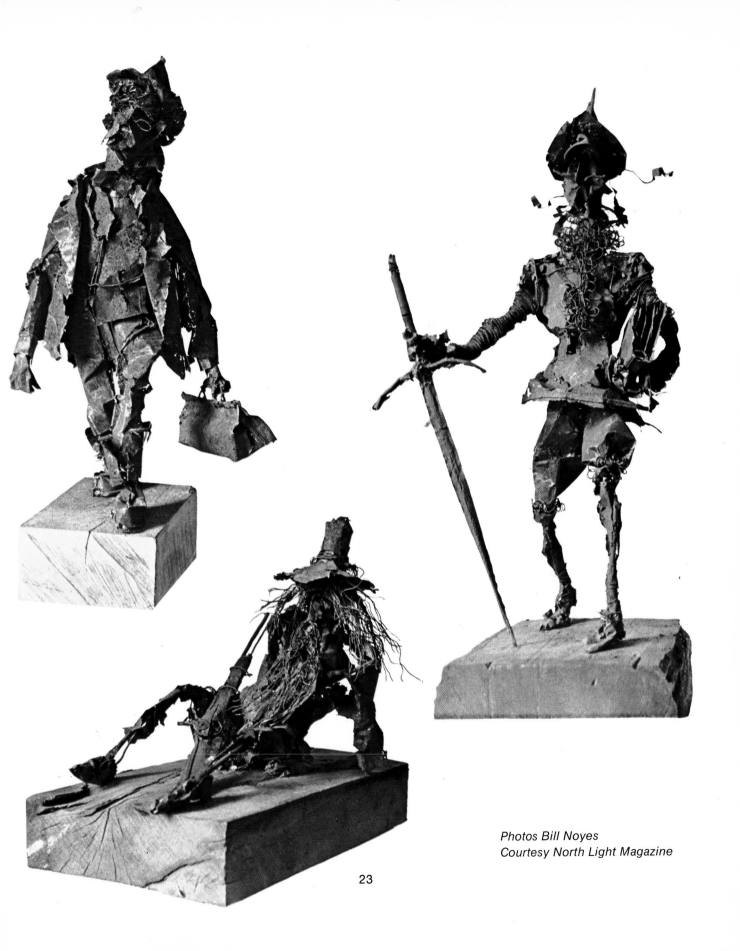

*Photos Bill Noyes*
*Courtesy North Light Magazine*

# Ellen Rixford

Usually, ideas just come to me. They can be the fruit of a long dialogue with my materials, or a big "Eureka!" while I'm brushing my teeth, but I've found that if I just ask a question aesthetically, the answer drops into my lap sooner or later.

Both the Stuffed Grandmother and the Seven Deadly Sins developed as a result of some horsing around with other projects which themselves never got finished. I had in mind to make a mask of some red leather a friend had left me, and was looking around for some old material to use in making a model. My hand fell upon an undershirt and I began cutting and puckering. When I held the thing up to look at it I was stunned.

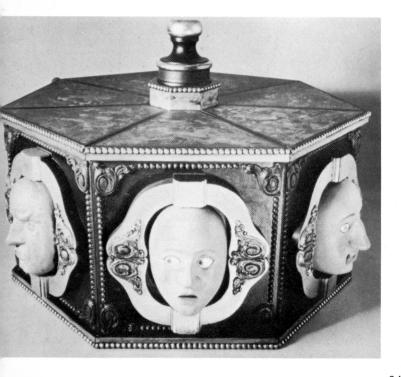

"I'm wonderful," it said. "You invented a whole new genre with me."

I made several faces, using undershirt material dyed a pale skin color, chose a finalist, and sewed the front of a dress for her. With most of the stuffed people I do now, a great deal of the work is finding the right cloth, feathers, trimming, for them. Half my working day passes scrounging in the trimming store asking for a yard of this and a bunch of that, and the other half passes squatting before the "person" holding things up from my pile, accepting and rejecting.

The people are bas-reliefs, sitting or standing inside picture frames which have scratch-resistant plastic doors which open on hinges so that the people can be touched and played with. On stuffed people like the Grandmother, the faces are so baggy and pliable that you can change the expression of the face completely by pulling on the nose a little, or turning the mouth up, down, or sideways. I love that part.

The expressiveness of a face is probably the most important element in the figures I do. This is how I got hooked into making the Seven Deadly Sins, a superlatively difficult and taxing problem in facial expression. I had been making some wooden masks just for fun; trying to make a series of facial grotesques; seeing how many different facial types I could invent. I went through a book on the history of painting, and when I'd find a good face, I would hew out the profile and take it from there. I had about five faces when the idea dawned on me to make the extravaganza of iconography—seven faces, representing each of the seven deadly sins, each face on one side of a seven sided box. From that point, I bent my efforts toward making each face look like the vice it represented, and

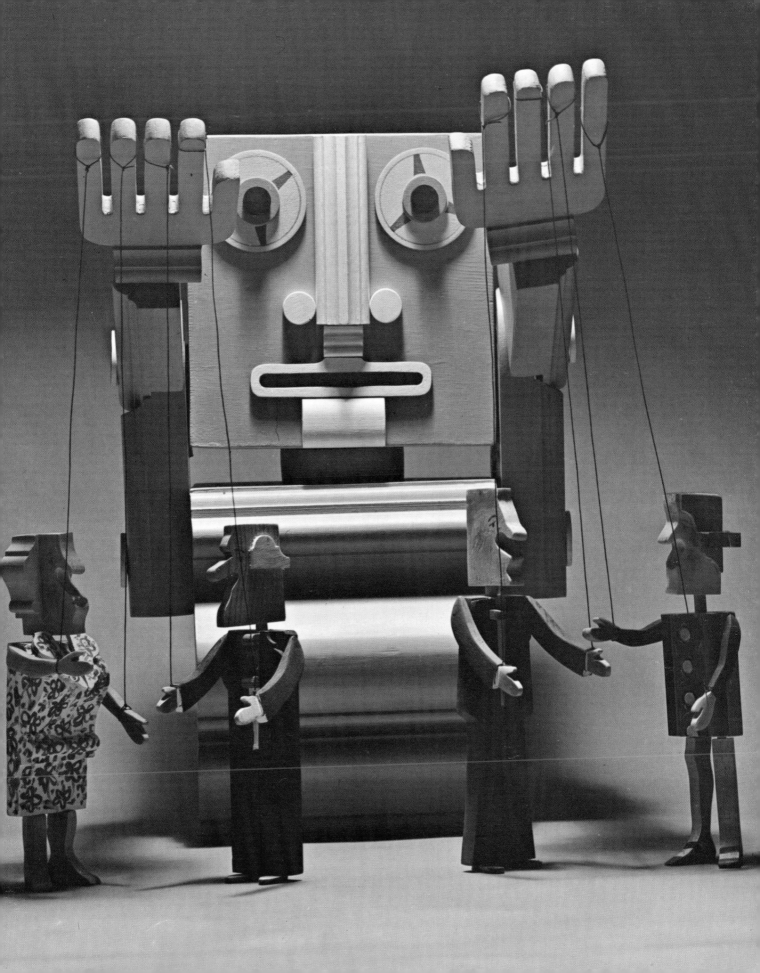

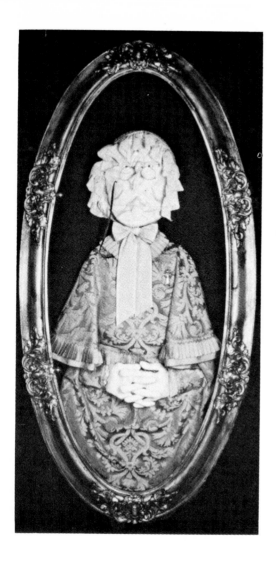

I didn't stop carving until I could put the faces before any visitor to my apartment, ask him/her which faces were which sins, and get nearly 100% correct answers from everybody.

I had read about the Bridge of Sighs in Venice, a spot where stood a prison for political offenders, and I remembered that they were sent to their doom by informers who dropped notes into the open mouths of some stone lions—notes which were collected by agents of the Doge. What if I made the mouths of my masks slightly open and arranged for the faces to be detachable from the box? You could drop notes into the box (through the mouths) informing on sinners and God would come along, detach the mask, stick his hand in through a hole behind it, collect the notes and send the sinners to Hell. When the piece got into the Illustrators' Show I put a label on it explaining this, and asking for notes. I got plenty. Wonderful ones.

There were many problems putting the box together, particularly since it is designed to come apart and fold up for storage. The sides come out, and the top and bottom fold, accordion-fashion, along the lines going from the corners to the center. But the technical problems were more cabinet-making than aesthetic. Somehow, somewhere, I've found, there is always the right hinge, the right tool. And if there isn't, I wait for an idea to come to me. And it does.

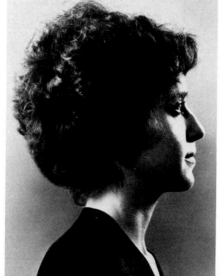

**Ellen Rixford**

*Born / New York City*

*Studied / Cooper Union and with: Reuben Kadish, Ed Casarella, John Kacere*

*Illustrated for / Magazines, pharmaceuticals, advertising agencies, also do sculpture which I sell privately*

*Exhibited / Waverly Gallery*

*Awards and Honors / Honorable mention Society of Illustrators, Gold Medal, Art Directors Annual Show*

26

# Vin Giuliani

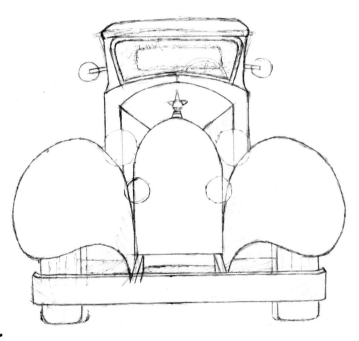

When you work with assemblage—or dimensional art—the approach to a given assignment is usually suggested by the Art Director and dictated by the needs of the client. In an ideal relationship, a fruitful exchange of ideas forms the basis for development of a concept. Depending on the latitude permissable in the context of the needs of the client, this concept varies in flexibility. Again, under ideal conditions, a joint exchange of viewpoints forms the basis of the work, but ultimately, the artist is responsible for the final form of the work.

The idea, as a visual or intellectual concept must remain the cornerstone of the work: it must be strong enough to carry the piece through to its final conclusion, after many changes and shifts in perspective.

The work illustrated—one of a series of six, designed for the annual report of the Scovill Manufacturing Company, presented special challenges. The client

*The original line sketch for Scovil Manufacturing Co.*

*The finished art for Scovil Manufacturing Co.
Annual Report.*

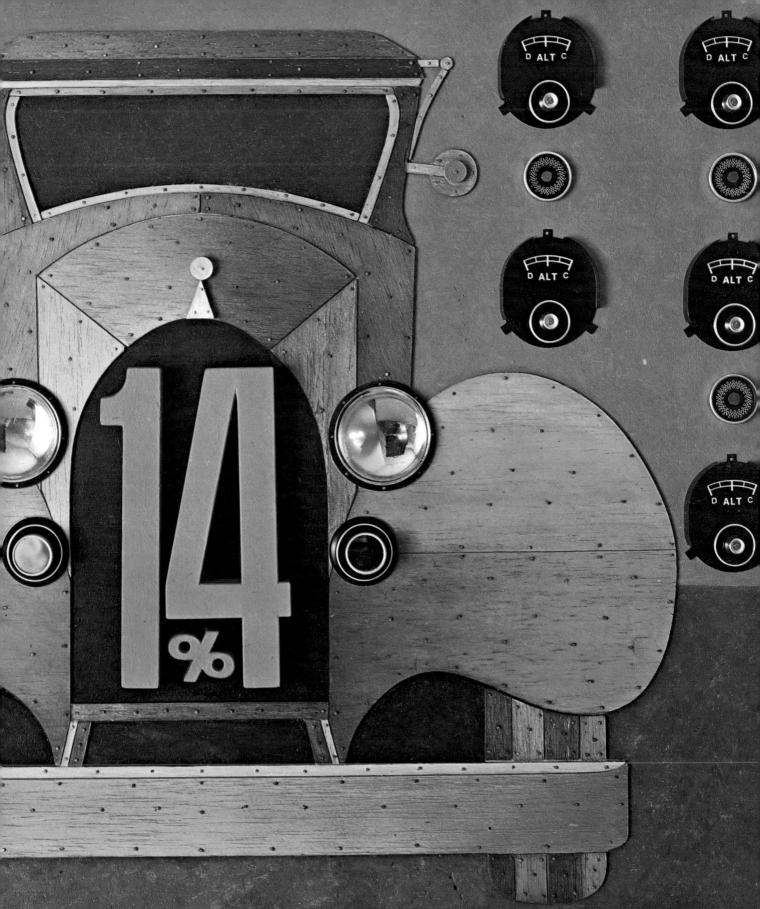

required the incorporation of their own product in the assemblages, as well as percentage numbers indicating the relative quantities of sales made by the company in its four major market categories.

Before beginning the project, it was necessary to select a representative range of the client's products. This choice had to be made with several ends in mind. The aesthetics of the objects, their potential as graphic symbols, and last but not least their relevance to the client's promotional needs.

In the work shown—which illustrates the company's percentage of sales from automotive parts—the forms of a vintage automobile readily suggest themselves. Not only because the classic cars of the 1930's recall an ideal of speed and progress, but also because the soft and elegant forms suggest a giant toy—in itself an appropriate image given the scale of the work.

The next stage began with a sketch. Initially clumsy, the first image was worked with tissue overlays and tracings until a refinement was reached.

This final sketch was then transferred to a seasoned wood panel, pre-cut to size.

The next phase was purely manual. And yet, the careful cutting of the thin wood veneers, was in fact pleasurable. The workmanship involved is strangely therapeutic. The knife cuts into the surface of the wood, sliding and curving around the preiphery of each shape, defining the next area to be worked on, until the puzzle is completed.

The penultimate step is perhaps the most mysterious and yet most satisfying of all. There is no way of pre-determining the relationship of the paint to the work. It is something that must be arrived at by patient exploration. The juxtaposition of color with color and color with form, gradually creates its own logic, its own momentum, until quite unexpectedly the work begins to be seen as a completed process.

There remains only one more task. The placing of the objects in their pre-determined positions within the design. Whether or not these objects are left in their pristine state, or modified by such devices as paint or by natural agents such as patinating, is again a part of the whole aesthetic and creative process which determines the ultimate format of the work.

**Vin Giuliani**

*Born / New York City*

*Studied / Pratt Institute*

*Illustrated for / Time, Life, Atlantic, Holiday, McCalls, Redbook, Playboy, Exxon, Eastern Air Lines, Benton & Bowles, Young & Rubicam, etc.*

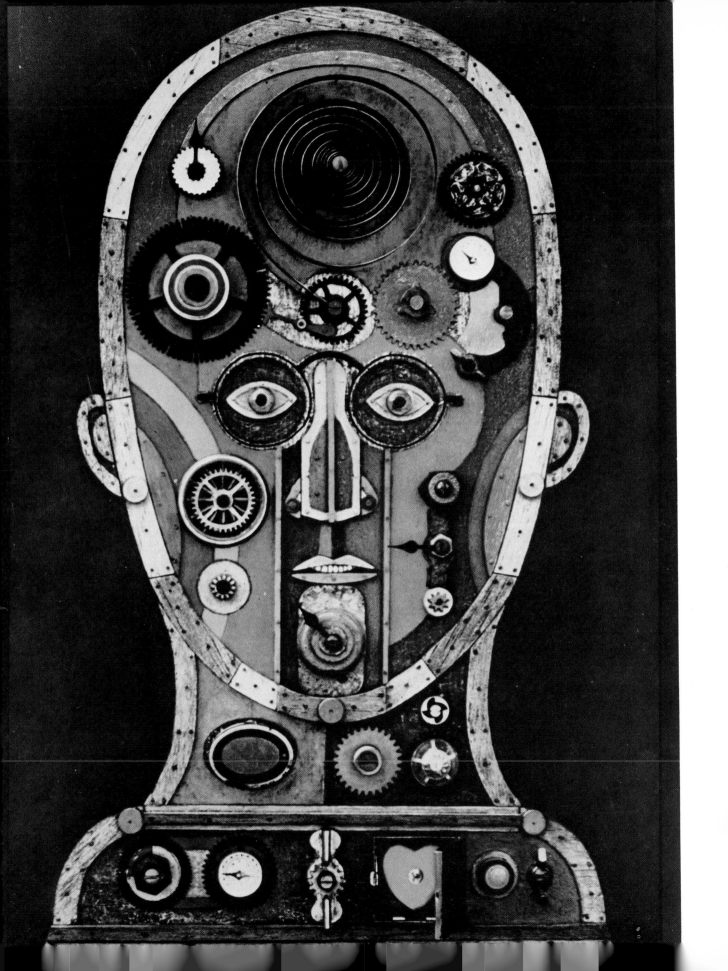

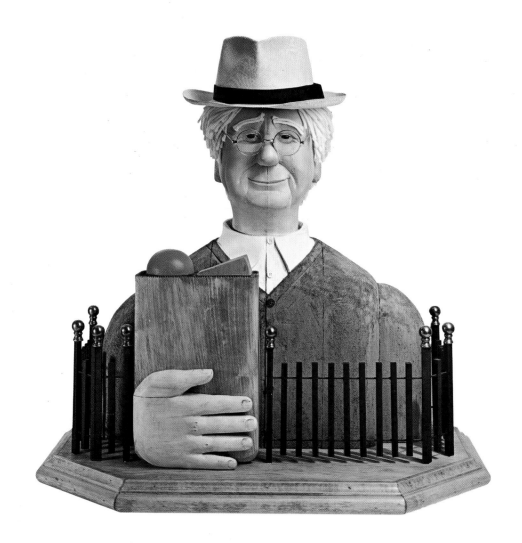

# Walter Einsel

This assignment was what could be called *challenging:* merely to do a larger than life-size sculpture of Walter Matthau as he appeared in the film "Kotch" made-up to portray a 72 year old grandfather. Also indicate the little park in which he spent considerable time and the groceries he frequently carried. *Do it in four days!*

I spent half the first day trying to track down large blocks of balsa wood. There is a premium on thick pieces of balsa that makes the fuel shortage seem *(cont. p. 37)*

Above: Walter Matthau as "KOTCH." *This is the result of an assignment from ABC Pictures to create an image to be used in posters and ads to promote a film featuring Walter Matthau portraying a 72 year old grandfather. The bag of groceries and the park fence featured prominently in his portrayal. The most difficult aspects of the assignment were: 1. To capture a reasonable likeness of Matthau as a man 20 years older. 2. Produce the finished piece in four days. It is made primarily of basswood.*

Victorian Doll House. *Built for Allied Van Lines for use in a television commercial, it is scaled 1" = 1 foot and measures 27" X 40" and 40" high excluding the flagpole. It has 19 windows. There are 250 feet of pine clapboard, mitered individually by the builder. The corner posts are mahogany, the cornice trim is of oak. The window trim is maple, the chimney: cedar. The roof is copper, aged with vinegar, salt, a propane torch and five hours of anxious patience. I say anxious because in order to meet the television production deadline I was given 6 days to produce it. On the seventh day I rested. The interior rooms are decorated with old fashioned wrapping papers, the floors are stained and waxed. The back is open to allow placement of doll furniture. The two end walls had to be constructed in such a way as to allow them to slide away in order to afford the T.V. production crew a cutaway view. This added to the anxiety quotient to which I alluded. The house contributed to a rather well-conceived, institutional-type of soft-sell commercial.*

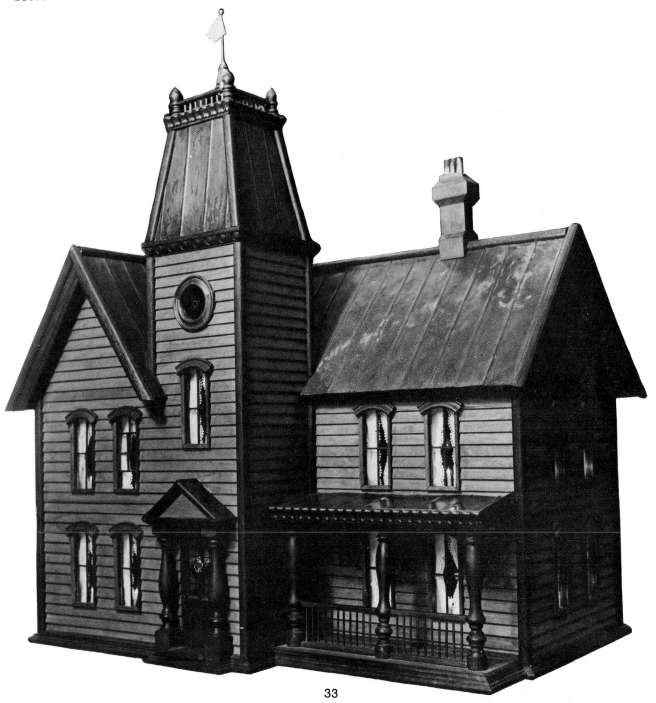

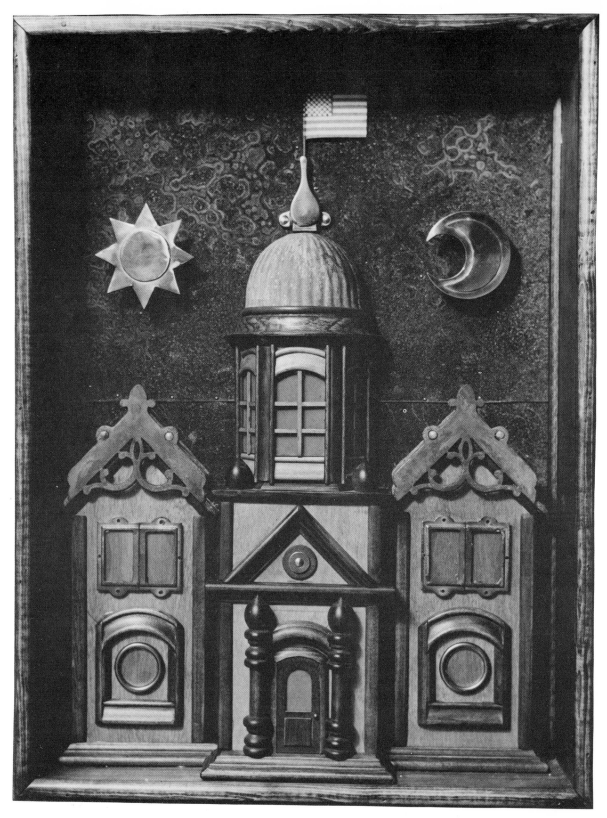

34

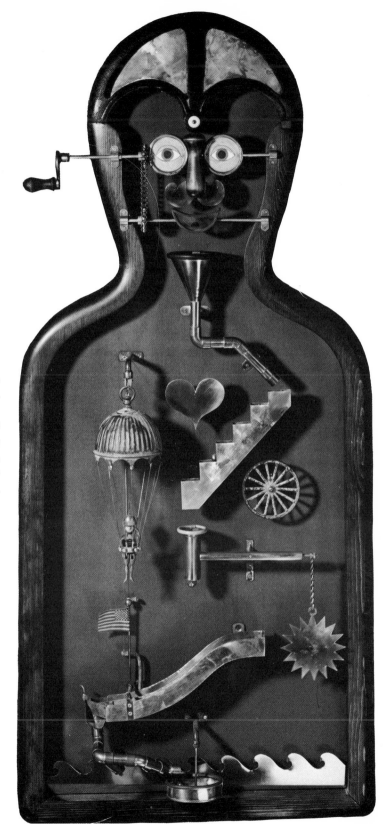

Left: *This architectural study has a shadow-box style of frame and measures 17" X 22". The materials consist of birch, mahogany, oak (in the capital cornice), copper and brass. The sun and the moon are of polished copper and brass, the sky in the background is old rusted metal from an abandoned oil drum. The peaked roof frontices are cast iron. The dome is part of a float from a toilet tank (copper). The windows are of colored plexiglas (orange and purple).*

Right: The Vitamin Man. *A black and white photograph fails to give the impact of the pool-table green felt background which sets off the polished brass and copper of the various internal parts. The eyes, in the first position, are closed. Turning the handle, after a steel ball is placed in the mouth, causes the eyes to open and the mouth to smile. The ball drops into the brass funnel and down through the copper tubing to the staircase. As it bounces down the stairs, it makes the brass heart quiver and then drops into a cylinder at one end of a balance. Its weight causes it to drop into the chute (at the same time making the sun rise). As it rolls down the chute, it hits a gate that makes the flag pop up and it ends its journey in an anchovy can. Raising the flag causes the parachutist to drop. The dimensions are 20" X 48".*

laughable. So, instead I used the bass wood I already had on hand. It was four inches thick. It carves beautifully. It's the softest of the hard woods but, of course, much slower going than balsa. After sketching the piece, roughly, in pencil, using the four inches as a module, I cut each section on the band saw. Because of the time element, I used contact cement. I prefer to use Elmer's glue and brace things together overnight. I started carving with mallet and chisels. I usually carve the nose separately and glue it in place so I don't have to carve away so much wood on the face. In the hacking-away period I did more refined sketches from photographs, searching for a reasonable likeness. As soon as the head began to look a little like Matthau, I rushed to a local optometrist, selected a pair of gold-rimmed glasses similar to the ones worn in the film, and ordered a pair of plain glass lenses installed. They were provided in two days. I chose white knitting wool for the hair since I was more interested in a strong textural effect than in realism (I hoped too, that it would photograph better than something more realistic). I finished the sweater area with a coarse rasp that, once painted, would resemble the texture of lambs wool. It was time-saving. The grocery bag is a block of the bass wood, the orange is part of a large wooden finial, sliced in half. The hand was carved separately and glued in place. The fence was made more effective by the use of brass finials found in a lamp repair shop. The fence is pine, painted flat black and held together with 1/8" dowels. Designing the base as a hexagonal with heavy moulding seemed to be a natural solution.

The piece was delivered *on schedule* to a photographer's studio where it was fitted with the Panama hat Matthau wore in the film. Following the studio shot it was whisked by taxi to Kennedy Airport to meet Jack Lemmon, the film's director. *My* Matthau and the *live* Mr. Lemmon were filmed sitting together on a park bench. All this in an effort to produce a smashing poster and advertising campaign for the movie. And it all worked beautifully until the very last moment when Radio City Music Hall, which premiered the picture, decided it didn't like the treatment and decided to go with a little black and white photo of Matthau and a very large full-color picture of one of the Rockettes. Show biz…the Art biz!

The Victorian doll house was designed and built for a T.V. commercial, one of several in a series of soft-sell advertisements for a moving company. The scale is one inch to the foot and measures 27" x 40" and is 40" high. It has 19 windows. There are 250' of pine clapboard, mitered individually on a radial saw. The corner posts are mahogany, the cornice trim is oak and the window trim is maple (usually used as cabinet door trim). All of these are available at lumber suppliers. The roof is copper flashing which I grooved to resemble a real roof and aged with vinegar and salt, a propane torch, and a lot of anxiety since I was racing the clock. It had to be completed in six days to meet the producer's shooting schedule. The interior rooms are decorated with old fashioned wrapping papers, as called for in the script (there was a voice-over describing some of the house's details). The floors are stained and waxed. The back is open. The two end walls had to be made to slide away to afford the cameraman a cut-away view. Two days before the deadline, the producer called to ask for the exact width of the house. The doorway through which it had to be carried allowed a clearance on each side of 1/8". Luck! In order to film it being carried, crated, up a set of stairs and into a child's bedroom, two crates had to be constructed: one that would fit through the doorway and another, larger one, put together around the doll house in the bedroom. Strangely enough it all worked and stranger still, the client actually runs the commercial, over and over again. I feel flattered that it seems to be the most effective of the series. Residuals would have given substance to the general glow but since the house has no speaking part, it doesn't qualify.

While at times it can be discouraging, I find three-dimensional work most stimulating and gratifying.

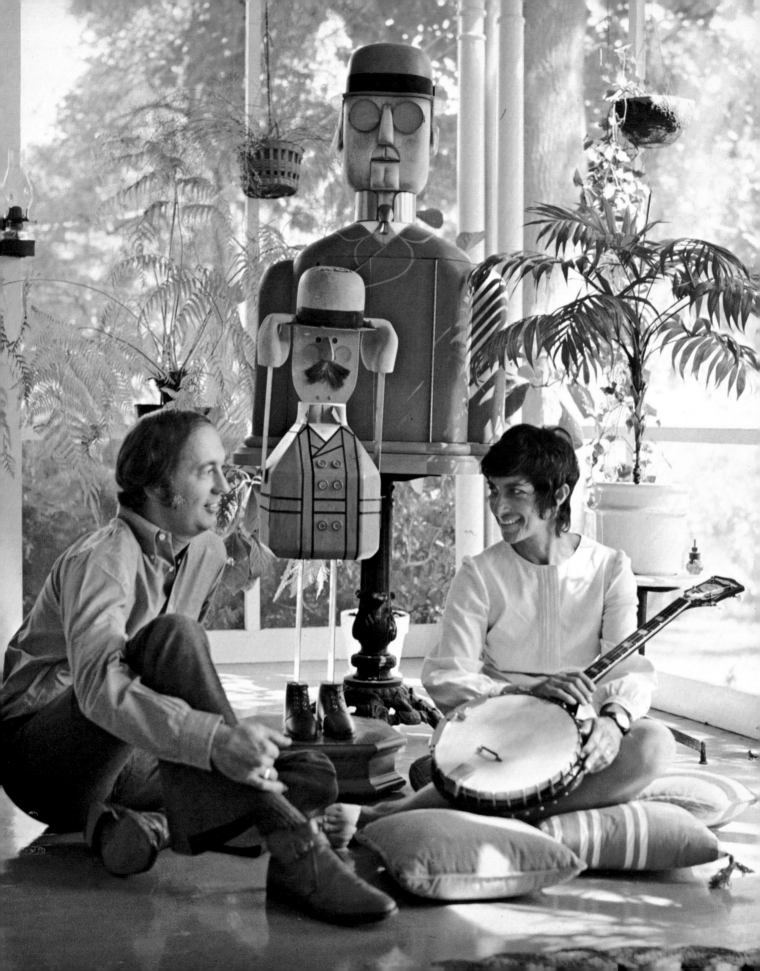

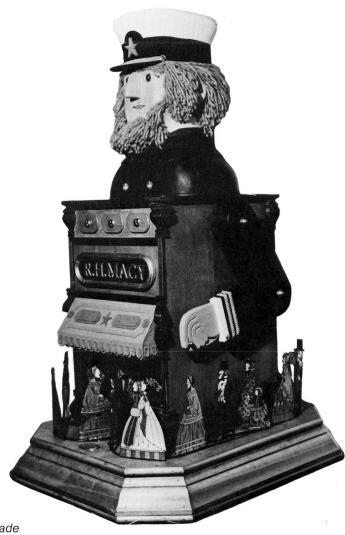

*Walter and artist-wife Naiad pose with hand-made friends for cover of North Light Magazine.*

*Photo by Bill Joli*

## Walter Einsel

*Born / New York City*

*Studied / Parsons School of Design,
Art Students League*

*Illustrated for / Macy's, National Magazines,
TV Commercials*

*Exhibited / Museum of Contemporary Crafts,
Man And His World, Montreal, Fairtree Gallery, N.Y.,
General Electric Gallery*

*Awards and Honors / Art Directors Club of N.Y., AIGA,
Society of Illustrators, Graphis, Penrose Annual*

*Art Affiliations / Society of Illustrators, Westport Artists*

Capt. Macy: *This object was created for Macy's to be used in connection with a promotion celebrating the 115th anniversary of the founding of the store. It is a representation of Captain Rowland H. Macy, the founder, mounted on a replica of the original store. It is over 4' tall and is run by electric motor. As the Captain slowly cranks his arms, the customers parade into the store. It was used in television commercials and then occupied a prime window of the store at Herald Square, New York City. A 14' replica was made by Macy's display department for use on the main floor.*

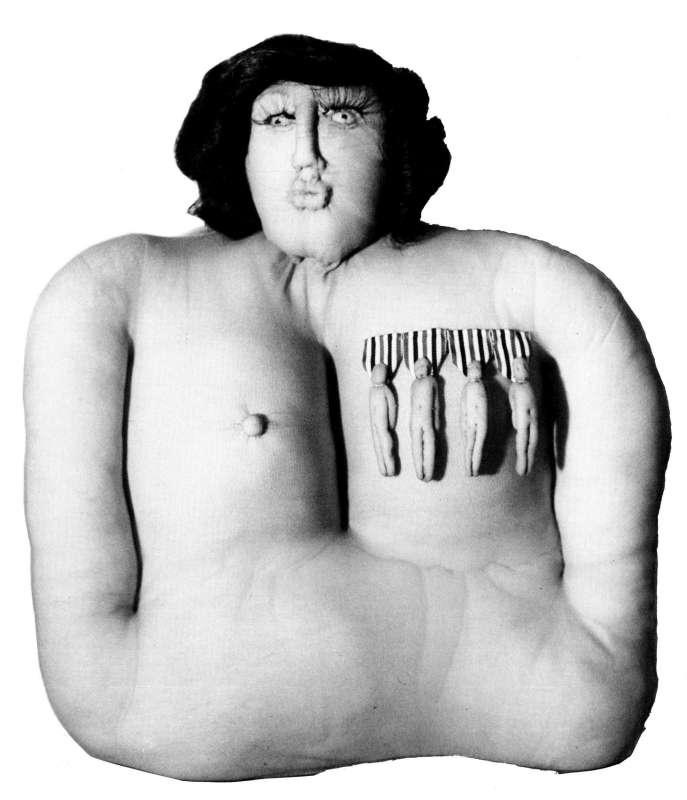

# Judith Jampel

In the beginning: a self-promotional publication... problem-solving coupled with "free" control led to experimentation with new forms, new materials...

In sculptural beginnings: Rudolf Arnheim, author of "Art and Visual Perception," says that every beginner in the art of sculpture discovers that the cubic concept imposes itself on his work, and that when he attempts to abandon it in favor of the sort of roundness of the Renaissance, he has to overcome the Egyptian in himself...with plaudits for the primitive (simplex form), I now attempt to overcome my original Egyptian by mastering complex form...

The studio: small...white walls...floor straw mats... long muslin-covered table along long wall...Fleetwood zig-zag sewing machine...white bookcases...shelves: needles, pins, scissors, snaps, screwdrivers, a wrench ...in plastic boxes: cotton, nylon, elastic threads...in plastic Glad bags: surgeon's gloves (size 6), men's tee-shirts (X-large), polyester fibre fill, synthetic hair, white bone suntan brown black red blue green sheer mesh Agilon Cantrece Monvelle pantyhose...

Form and substance: not a random choice of materials...material selection determines form...my matter and form determined material (as a girl-child, as a woman)...memories of doll-playing...female societal indoctrination with cosmetic materials, cosmetic surgery (sewing)...nylon stockings as idealized skin... using female experience as source...synthetic perfect skin liberated to serve as natural non-perfect skin...

Development: (1) dancer, actress...involvement in non-visual arts...perspective of time; (2) artist, designer—two-dimensional...involvement in visual art . . . perspective of space; (3) sculptor—three-dimensional...attempt to combine perspectives of time and space...work that moves...inherently static ...inherently sequential...inanimate actors...

*Photo by Ben David Jampel*

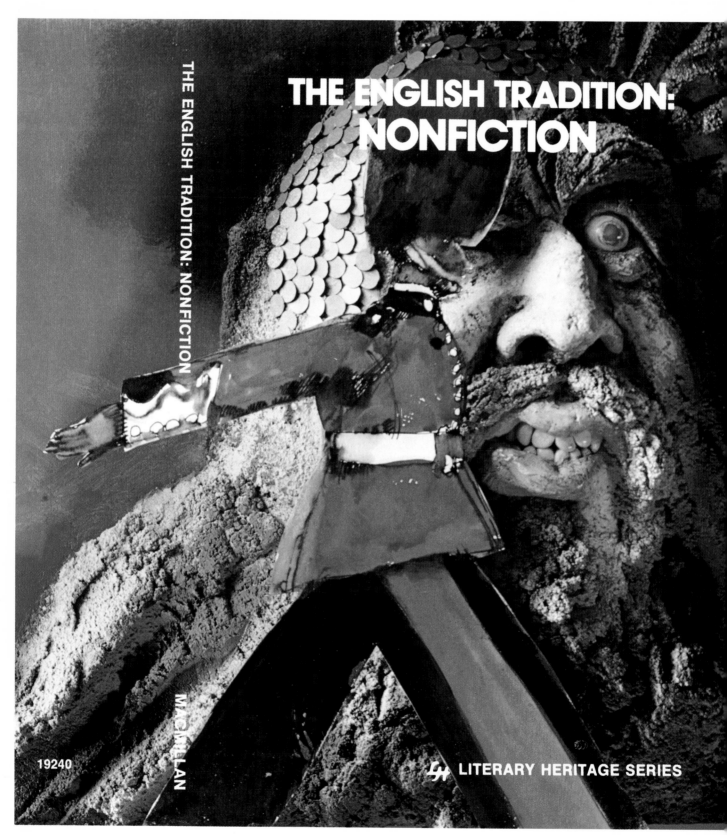

# THE ENGLISH TRADITION: NONFICTION

THE ENGLISH TRADITION: NONFICTION

MACMILLAN

19240

**LITERARY HERITAGE SERIES**

# William S. Shields, Jr.

The theme for this illustration was English literature, sub title "NON-FICTION." It was one of a series of book covers all executed in the same medium. Since this was non-fiction, I wanted the people illustrated to have a feeling of existing or having existed in English history, hence the uniform of the present day guardsman. The large face represents one of the colorful kings or perhaps one of the knights of the round-table. I want to leave this up to the viewer's imagination.

The medium I used for the major part of the illustration was brown coat plaster, a material available at a builder's supply shop. This can be embellished by absolutely anything as long as it works to express a mood or texture. An example would be the beans I used for the teeth, a marble for the eye and roofing nails for the chain mail headgear.

After you mix the plaster with water, it is essential to work very rapidly and spontaneously as the plaster will set up in 15 to 20 minutes. From that point on, you can only modify the sculpture by carving or adding new malleable plaster to the hard surfaces. I usually leave the sculpture overnight to dry out a bit and then work on it with chisels, knives and sandpaper. You can do almost anything to it providing you realize its limitations. When it is completely dry (which can be expedited by heat) I paint it with water base paints and glazes.

The guardsman was painted on illustration board and cut out. It is mounted on a piece of wood that extends upward from the face. I thought the flat look contrasted nicely with the modelling of the face.

When all the elements are finished and in place, the sculpture is ready for a most critical step—photographing it for reproduction. This can be fascinating because you have a chance to exaggerate the elements and add mood and flavor to the sculpture. I experiment by moving my lights in every possible direction to see how it effects the figure's features. In this instance I used an additional red light as a fill to cast a warm glow on the side of the face. I did this to give an added lusty feeling to the knight.

This is a very expressive medium and one that allows your characters to come alive in your hands and to watch their expressions change with the pressure of your fingertips.

43

*A recent manner of working: wood fragments (found and fashioned) wire, rusted tin, beer can tabs, beans, brads and boards.*

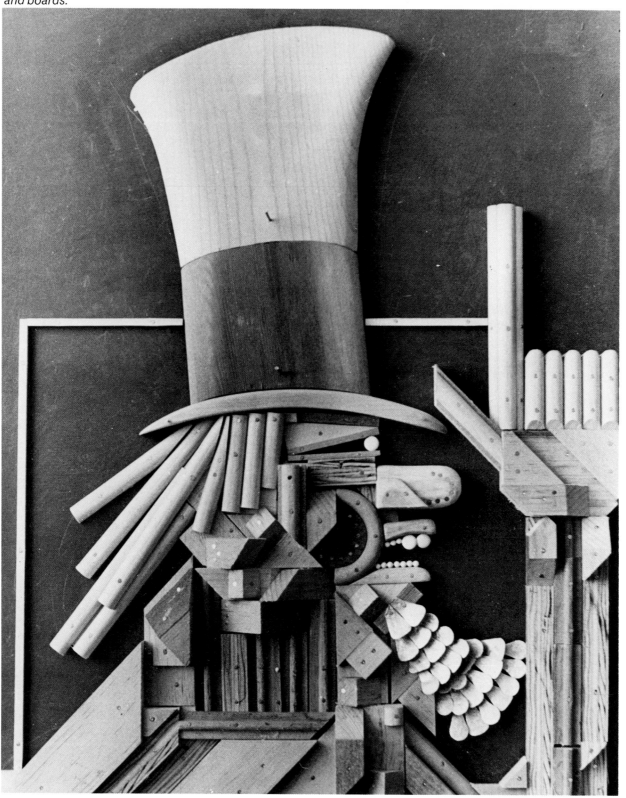

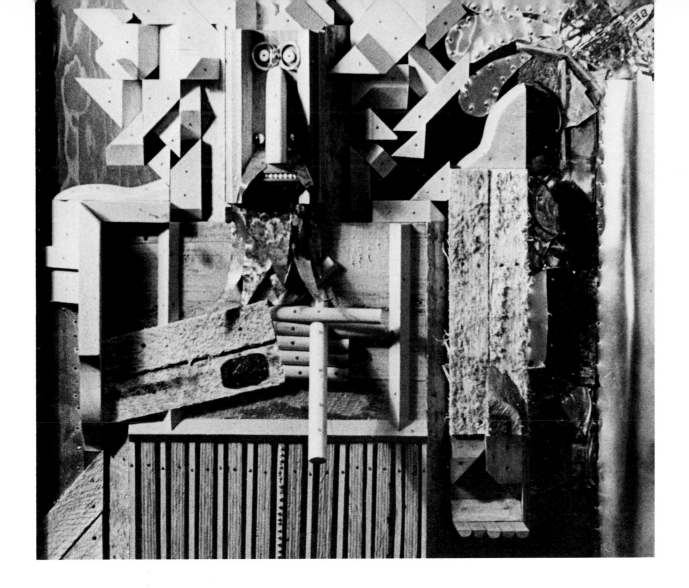

**William S. Shields, Jr.**

*Born / San Francisco, California*

*Studied / Chicago Academy of Fine Arts,
San Antonio Art Institute*

*Illustrated for / National magazines, book jackets,
trade books*

*Exhibited / Galleries in Houston, San Francisco,
New York, Westport, General Electric Gallery,
Fairfield, Ct.*

*Awards and Honors / Gold Medals in New York and
Los Angeles Society of Illustrators*

*Art Affiliations / Society of Illustrators,
Westport Artists*

45

# Blake Hampton

The tail end of the Ozarks snakes down through Arkansas and into Eastern Oklahoma where they are called the Ouachita Mountains. My earliest recollections are of sitting on our back porch and looking out at those blue, lavender, and grey mountains in the distance. I always wondered what was on the other side of those mountains. I realize now this probably was the first time I thought dimensionally.

The impetus which started my sculpting career was a bone-handled "three-blader" given to me by my grandfather when I was seven. For the next few years I tried to emulate the old whittlers who sat and whittled by the hour in front of the feed store, the domino parlor, or around the court house. I remember one panama-hatted, bib-overalled old ex-miner who, in three days would whittle a nine-inch length of chain connected to the "clasped hands" connected to the classic caged ball, all from one piece of pine.

My father, who is now a longhorn craftsman, was also an inspiration in dimensional expression. My brothers and I would describe a toy we had seen in town and then my father would carve and construct it out of apple boxes.

Later I had formal training in sculpture with Octavio Medellin and William Zorach, but my interest now turned toward a career in commercial art. After a B.A. in advertising design, I came to New York where I landed at Sudler & Hennessey, a pharmaceutical agency. Here I was able to utilize my background in sculpture. Since there are only so many ways you can render the urinary tract, new approaches were needed. I worked in clay, plaster, balsa wood, hard woods, plexiglass, acetate, lucite, metals, ivory, styrofoam and sand, but I always came back to paper sculpture for a pure, simple statement.

I appreciated the advantages of paper sculpture such as the fresh approach it gave to worn-out subjects. I used paper sculpture to handle delicate subjects such as sex education in "How Babies Are Made." Also, because of the real dimension it can

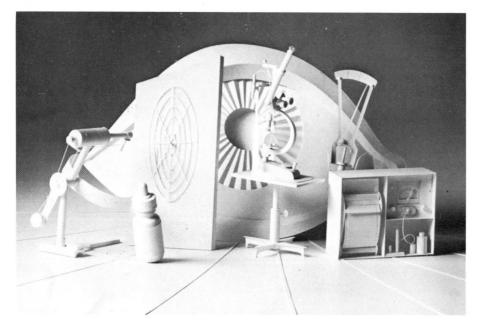

*Mostly paper. For Ayerst Laboratories*

*Arms and armor are a favorite subject. This was a cover for a children's Book Week Festival. It's mostly white on white paper with foil and polychromed wood added. The face is balsa wood.*

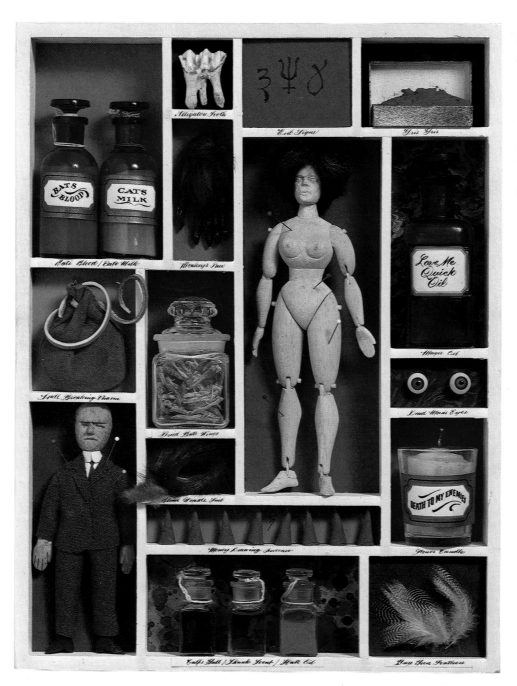

One of my early pieces. The scarf and muffler were cut from magazine photos of material.

A construction for True Magazine about occult products. Both voodoo dolls were carved. Everything else was bought or found.

more graphically explain mechanical and physical functions such as the workings of a piston or the valves of the heart.

My paper sculpture illustrations begin like any other illustration. First the tissue is worked out, submitted to the client, and when approved, it becomes my working drawing. If the job is to be in color, the next step is to work out the color and texture relationships. If supplementary materials are called for these are selected and included in a mockup of the design. These supplementary materials may include decorative papers, foils, feathers, beads, rhinestones, leather cloth, fur and any object which might be in scale. When I'm satisfied with the composition, the materials are then rubber cemented onto the base paper. I haven't found anything better for a base paper than one-ply kid-finish Strathmore. The paper holds its shape, scores well and will curl without curdling.

The working drawing is transferred piece by piece to the reverse side of the base paper. Since the tissue or working drawing was drawn as the piece would appear finished, allowances have to be made for the curves. In other words, the individual pieces have to be "fattened" before cutting. The basic cutting tool I use is an Exacto knife with a No. 11 blade. Cuticle scissors or tiny origami scissors are very handy for trimming. After cutting, the pieces are formed and fitted together before gluing. This is the trial-and-error phase of paper sculpture. Sometimes as many as ten different pieces will have to be cut and discarded before one fits properly. It must be remembered that paper sculpture is an illusion. You create a bas relief sculpture to look as if it is full round. Once the pieces fit correctly, it is time to glue them together or in place. This is the tedious phase of paper sculpture. A curved piece will retain some tension so therefore the piece must be held motionless until the glue sets. My basic glue is Elmer's white glue. It dries matte and transparent.

If the sculpture is to be used as an illustration, the photography is critical. One should supervise the photography if possible. When constructing a paper sculpture illustration, I work with one light source. When the piece is lit for photography from the same angle, then the maximum dimension should appear. To me paper sculpture is fascinating because it is a constant learning process. Every new piece brings with it a new illusion problem to be solved.

Whenever I look out on distant mountains I still think dimensionally and still wonder what is on the other side.

**Blake Hampton**

*Born / Poteau, Oklahoma*

*Studied / Dallas Museum of Fine Arts*

*Illustrated for / National and medical magazines and major advertising agencies and broadcast companies*

*Exhibited / Art Directors Clubs of New York, Dallas, Philadelphia, Boston—one man show, Waco, Texas*

*Awards / AIGA Show, Society of Illustrators Annual Exhibits, New York Art Directors Club Journal of Commercial Art*

*Art Affiliation / Society of Illustrators*

49

# Al Pisano

Chuck McMains, F.W. Woolworth's New York art director asked me to design a poster for their annual candy sale. The promotion was called "Candy Carnival." I had a quick reaction to just how I wanted it to look: nostalgic, antique, colorful—a festival of candy and color! It should have the quality of a sign used for a country store at the turn of the century—unearthed after many years from an attic or an old barn.

After some rough idea sketches and a discussion with Chuck, it was agreed to feature the old apothecary jars used in ice cream parlors years ago. The typefaces of course would be from the same period.

When I got down to work I first transferred my drawing onto the wood with carbon paper. I used a router to "rough out" the excess quickly. The real carving begins after that. That's when I turn to hand chisels. First, I carved the jars and the candy and finally the lettering. When I was satisfied with it as a plain wood carving, I was ready to decorate. It's a great temptation to get stain and color on as soon as you can. Too soon sometimes. I used dark and light stains in different parts of the carving...darker for the center and lighter for the outer edges. I had to stain it several times with different water colors to achieve the antique look I wanted. When the stains had penetrated the wood and thoroughly dried, I used acrylic paints for colors, but toned them down for the old faded look. Acrylics take to the wood well...do not seep too deep into the pores. And you can do a lot with them in terms of color. Happily, they also dry quickly.

When the paint is dry it's time to "distress" the piece to achieve the antique touch. For this I used small chisels and a mallet. I cracked the wood in strategic places. Then I applied more paint. Then, cracked it some more.

To get the look I wanted for this piece, I had to alternate several times between painting and distressing.

Finally, I was pleased and Woolworth's was pleased. You can't wind up with a happier ending than that.

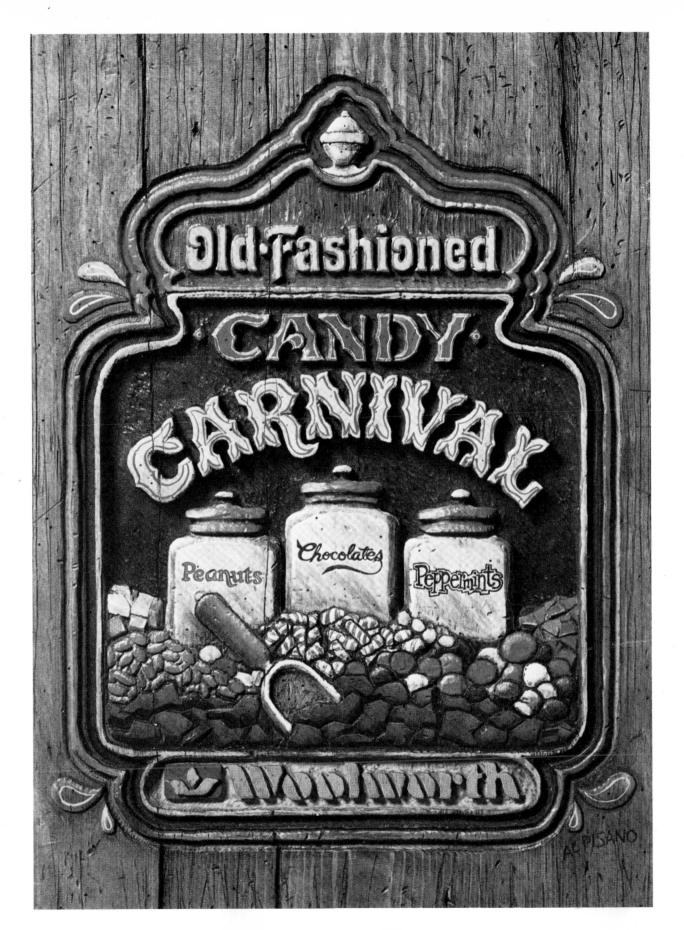

**Al Pisano**

*Born / New York City*

*Studied / School of Industrial Arts,
Pratt / Visual Arts*

*Has Illustrated for / Dell / Grosset Dunlap,
Mcmillan, Lancer, General Foods, Campbell,
National Distillers, Taylor Wine, Advertising
Agencies, Studios Point of Purchase*

*Awards / Society of Illustrators*

*Art Affiliation / Society of Illustrators*

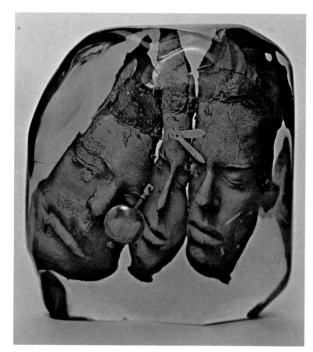

3

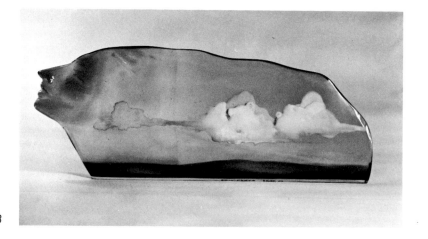

# Nick Aristovulous

1

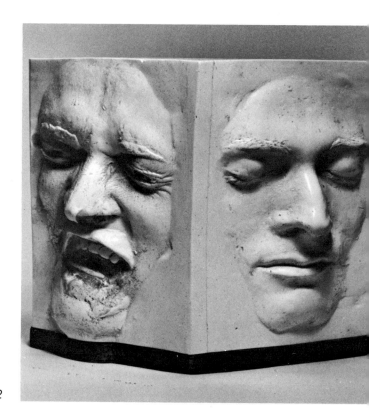

2

1. When this particular piece was done I had already been working with polyester resin for some time. I found it to be a slow, time consuming medium but one that had exciting visual qualities if handled properly. Nothing similar was being attempted in illustration and I wanted to see if I could make it work.

This piece was one of several which I experimented with to see how the refractions of the plastic affected objects encased within. Photographed from different angles, the three heads took on different appearances. Anyone who works with reflective three dimensional materials has to be prepared to see his work in those terms.

2. The heads were identical to begin with but by stretching and distorting the rubber masks, I achieved the elongated appearance. Then they were encased in a block of resin which had to be built up slowly around them. The actual pouring and drying of the plastic took more than a week. I wanted the work to appear cold and futuristic and have a timelessness about it…a disembodied and dreamlike effect. The three heads in the block still didn't have that effect because of a definite strong shape of the cube. My solution was to soften the edges by sanding and altering the shape and contour to give me the effect that I wanted.

This work was done a year later.

At the time I was searching for still newer ways of using the resin, other than just encasing objects in it. I had begun to realize that my pieces by then had taken on a very somber, rigid style. I tried to loosen up my ways of working and thinking. I sought to revamp my attitudes. I also wanted to make the material I was working with more flexible using more color, combining textures on the outside surfaces, leaving some areas rough and polishing others.

3. This piece is about an inch thick. I worked it up first in clay. I later cast it in clear resin and then by building up the clouds and landscape from the back, I tried to suggest a wide open distance. I wanted the woman's profile to have a proud, flowing look and a sense of freedom—like a breath of clean mountain air.

The back of this sculpture is completely flat. The only relief is on the woman's face.

This whole new departure was responsible for making me realize the different possibilities that could happen with my medium. It was a totally experimental piece and I was quite satisfied with the results at the time. Looking at it now, I see many technical mistakes, such as the unintentional bunching up of the color towards the face, or the small spatters that occurred during curing due to the catalytic heat. But, then again, that was part of my learning process, little personal reminders that belong to each artist alone.

**Nick Aristovulos**

*Born / Athens, Greece*

*Studied / School of Visual Arts, Studied with: Robert Weaver, Robert Shore, Wilson McClean*

*Illustrated for / Playboy, Seventeen, Intellectual Digest, Look, RCA Records, Atlantic Records, Dell Books, Doubleday, Harper & Row, Holt, Rhinehart*

*Exhibited / Society of Illustrators*

*Awards and Honors / Gold Medal '72, '74*

The Case of the Empty Tin. *A used beer can was put on a clay block and both were sprayed gold. Skull and crossbones label and girl's head were then pasted on. Photographed on black velvet in color for reproduction.*

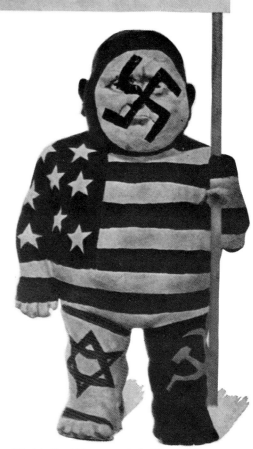

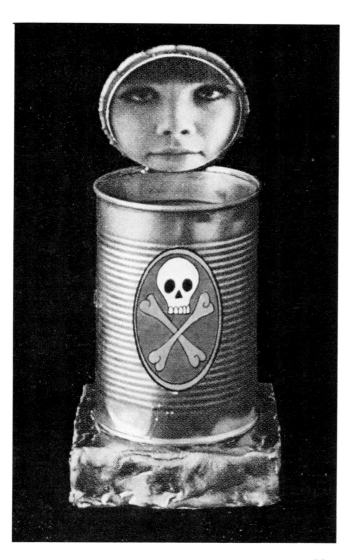

Mother Night. *Kurt Vonnegut, Jr. The sculpture of* Mother Night *is an example of understanding the author's significance, digesting the novel and arriving at the most effective symbol. It was done in 1961 and the book is still being reprinted with the same cover. The sculpture was made of clay and painted with casein paint. The pole is a wooden dowel and the flag is Bristol board. It was then photographed in color for reproduction.*

# Milton Charles

Transforming the written word into a visual symbol that communicates its very essence is, and has been, my major concern for many years. I have always been involved in the conceptual area of graphics. Most of my work for the past fifteen years has been in publishing. Whether I perform as a designer, designer-illustrator, designer-illustrator-photographer, or art director, reading the manuscript and arriving at an interesting, exciting, intriguing and sometimes provocative symbol is the most significant part of my work.

In 1959 I was commissioned to do a series of books each dealing with a famous personality. An intellectual concept was not required here but since there were many similar lines of books available, I felt that an unusual graphic concept was vital. Book covers with paintings, drawings or photographs of celebrities had been done many times before. It suddenly occurred to me that there was one other medium which had not yet been used—sculpture. It seemed to have the potential but also presented many problems. How to present it? How to reproduce it? I decided to try. Clay sculptures were made and I photographed them from many angles using varied lighting effects. The result was truly three-dimensional. The client was somewhat alarmed because he had never seen anything quite like it before, (I submitted 4 x 5 color transparencies). However, he agreed to go ahead. This was the beginning.

From that point on I started thinking three-dimensional art. I was convinced there was nothing I could conceive of that could not be either found, built or sculpted, and that this type of graphic solution would be fresh and unique. The materials I used were varied. I used a combination of earth and rubber cement; wire, wood, lucite, paper, concave and convex mirrors, bricks, rocks, and, of course, clay sculptures and wood carvings. Many of these were combined with drawing

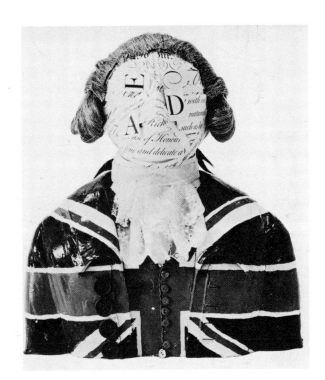

Eighteenth Century English Drama. *This concept is purely graphic. The figure was constructed of clay and painted with casein. Synthetic hair was used for the head, real lace for the shirt, actual buttons on the jacket, and a montage of old type specimens for the face. It was then photographed in color for reproduction.*

Revolt in April. *The entire illustration was made of clay and sprayed white. It was photographed in color for reproduction using a pink spotlight on the hand.*

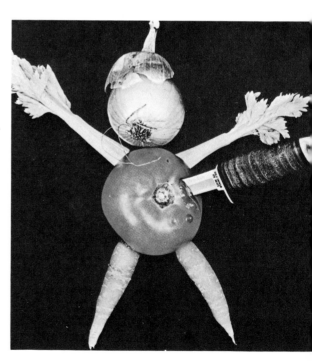

Ellery Queen's Crookbook. *This figure was constructed of fresh vegetables and a real knife, placed on black velvet, and photographed in color for reproduction.*

and painting. Fire also became a very important element in combination with these structures. I experimented and discovered that rubber cement was the secret to controlling the flame. If rubber cement were spread only on the area where flame was required, the fire would die when the rubber cement was burned up. The flame had to be photographed when it reached the correct height for the design. Sometimes as many as ten photographs had to be taken, each time spreading the rubber cement on the area required, lighting it, and then shooting when the flame appeared correct to me.

I feel that scope of three-dimensional art is boundless. The varieties of materials which can be employed are infinite and when the dimensional is well conceived and executed any message can be conveyed with striking imagery. My dimensionals have been successful from both the commercial and the artistic standpoint. The books have sold well and have won numerous awards from CA Annual, Graphis Annual, AIGA and Society of Illustrators.

The Indestructible Jews. *The title was built of clay and sprayed to look as though it were carved from stone. It was then photographed in color for reproduction.*

**Milton Charles**

*Born / New York City*

*Studied / P.S. 127, Newton H.S., Pratt Institute, Art Students League, Studied with: Morris Kantor, Jean Liberte*

*Illustrated for / Bantam Books, Simon & Schuster, Pocket Books, World Publishing, Signet Books, Fawcett Books*

*Exhibited / Weyhe & Salpeter Galleries*

*Awards and Honors / AIGA, CA Annual, Society of Illustrators, Art Directors Gold Medal 1973, Graphis Annual*

*Art Affiliations / Society of Illustrators, AIGA*

59

# The Dillons, Diane & Leo

This relief piece for "The Sea and the Jungle" was done in bass wood. We started with a pencil rendering of our interpretation of the book, each panel depicting a different stage of the authors' travels—from London to the jungles of South America. This was to show Edward Hamilton, the art director, what we had in mind and secondly to use as a guide for the different levels of the relief.

With deadlines in mind, we decided on a soft wood thinking it would be easier to carve. With the same thought in mind, we bought a dremel hand tool to rough out the levels before getting into fine detail. The soft wood fuzzed and collected around the tool so we couldn't see what we were doing. We ended up using traditional wood carving tools plus the #11 X-acto knife. The soft wood also tended to leave a rough surface so we used fine sandpaper and our electric eraser for smoothing out and finishing the surface.

There were five separate panels. Each of us took a separate panel and worked whenever we could till they were all finished, then we mounted and glued them to one large panel. It was then stained with a thinned-down walnut stain and finally waxed.

We made the deadline after a final stretch of 86 hours continuous work. Needless to say, we looked like two nodding junkies when we staggered in to deliver it. We went home and slept for 17 hours, straight through.

Why do we knock ourselves out? As illustrators, we have always tried not to limit our thinking or our effort. We are in the business of re-stating words into graphic images and one of our standards is to try always to do something new and original. The last thing we'd want to happen would be to be pigeon-holed as "specialist" in anything. This approach has led us in many directions: stained glass, crewel work, intarsia and clay. Of course this was back in the late 50's and early 60's when illustration was more two dimensional. It has since taken a healthy turn into the third dimension.

Our intention now is to work increasingly in three dimension. That probably will mean even less sleep and more hectic deadlines—but that goes with the franchise—as everyone else in this book well knows.

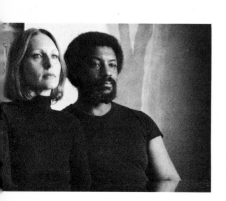

**The Dillons, Leo & Diane**

*Born / He, Brooklyn, N.Y.*
*She, Glendale, California*

*Studied / Both, Parsons, School of Visual Arts, AIGA Workshop*

*Illustrated for / Book publishers, paperback publishers, album covers*

*Awards / Society of Illustrators Annual, Art Directors Club, American Library Assn.*

*Art Affiliations / Society of Illustrators, Graphic Artists Guild*

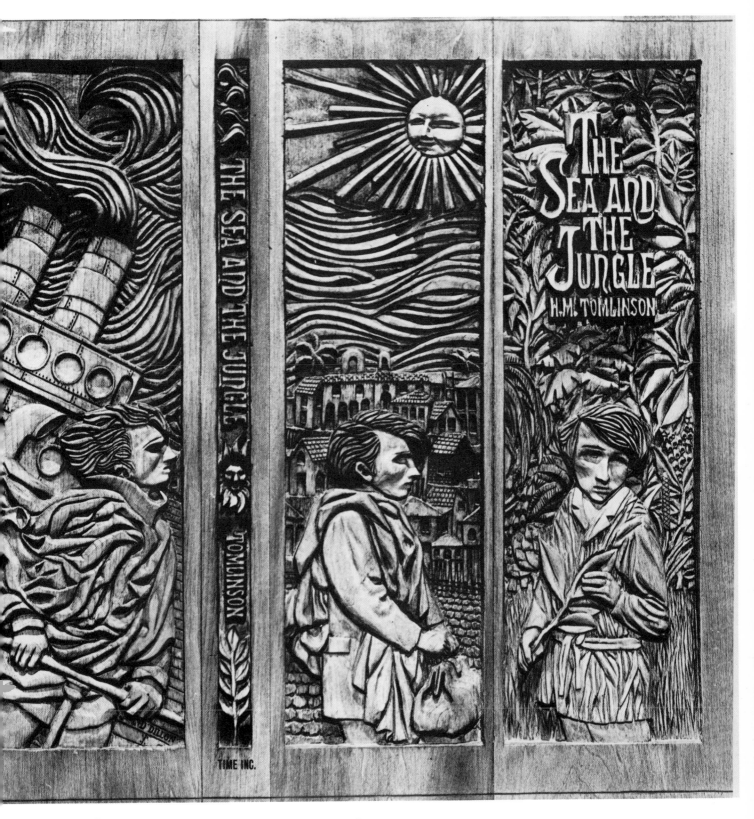

*Award of Excellence, S.O.I. Annual Show. Ginn and Co., publisher.*

# Raymond Ameijide

It's nice to do preliminary sketches and even finished art without reference or guidance. It's nice to do the job without submitting the preliminaries. It's nice never to make changes for the client. Nice, logical and conducive—all flow, no impedance.

What a client wants is your personality—where you're at in your own process. He's in a process of his own and neither of you needs all that hesitance over sub-totals. If you and your client are competent, there's little need to interfere with each other.

A paper or felt sculpture has lots of pieces to cut and join—like plumbing that you're going to photograph. It can use a master drawing. But the sculpture is three dimensional and comes to your intentions only when it's modelled by light.

You can do it when you do it but you can't draw it. You can draw for general composition, size, content, style, etc. Avoid indicating colors or values and their amalgams in the sketch; they'll be different in the finish. In any case, you don't want the two-dimensional orthodoxy to dominate the sculpture—no starting as an artist and finishing as an android.

When ready (sketch approved) do the drawing at working size with a soft, dark pencil; single lining every shape on a medium weight tracing paper. Spray fix the drawing, rub in a light blue pastel on its face

*Made of baked dough*

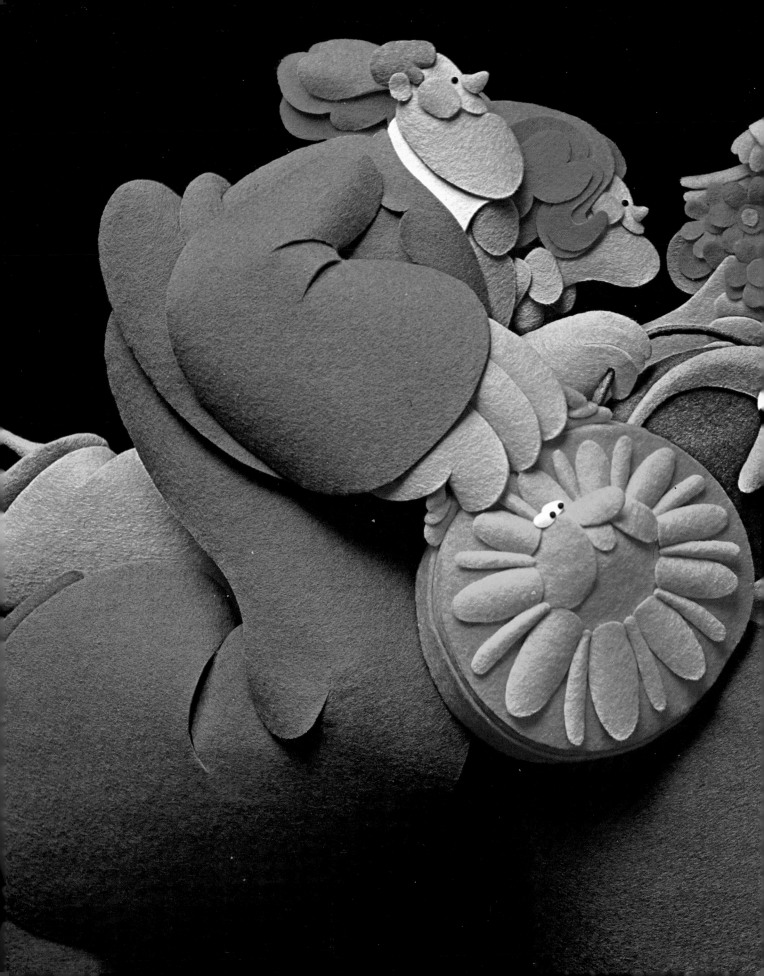

as your transfer medium. Select colors from the actual stock to be used. If it's a felt sculpture, you've already laminated the felt colors to a white paper backing (such as a heavy bond) and, when shapes are cut from it, you'll color the paper along the edges with markers to match the felt face.

Trace shapes in reverse onto the backside of the paper, distort them to allow for bends and curves and complete them (arm goes into sleeve) to allow for overlaps and hidden glue points. Use a 6H pencil.

You can bend the paper along a scored line (indented from the back) or curl it against a smooth round rod. Sharp or gentle curls or bends will take light differently.

Place your work light to simulate the light source as you expect it will be for the photograph. Assemble the sculpture piece by piece, to that light. Change whatever doesn't work for you under that light even if it looked good in the drawing. Follow the logic inherent in your plumbing—this piece is joined, then that piece.

You are the maker-viewer, the primary client. When you're satisfied with your work, photograph it (single strobe with umbrella-like sunlight). Deliver the pictures and go on to something else.

*First, the individual figures were made in proportion and lastly the couch was made to fit under them.*

65

...tesy First National City Travelers Checks ■ Series designed by Richard Lockw...

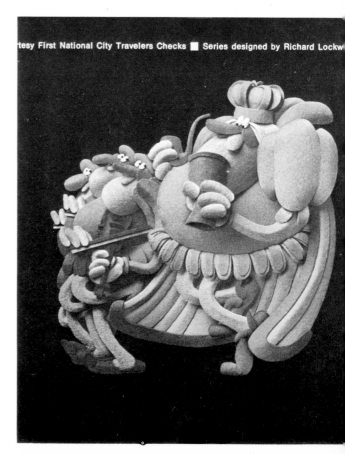

*Another dough piece*

*Courtesy First National City Bank*

**Ray Ameijide**
*Born / Newark, New Jersey*
*Education / B.A. Illustration, Pratt Institute*
*Illustrated for / Advertising, editorial,*
*institutional*
*Awards and Honors / About fifteen, including*
*Gold Medal and Hamilton King Award from*
*Society of Illustrators*
*Art Affiliation / Society of Illustrators*

# Gerry Gersten

I owe a lot to Herb Bleiweiss, art director of *Ladies Home Journal.* Up until the time he asked me to "take a crack at John Wayne" I had never done a three dimensional job for commercial use except for the candy and cookie castles I did for Xmas issues.

Until then my ventures into the world of papier-maché consisted of making little masks to wile away rainy day hours during summer vacation from P.S. 75 in the Bronx. That was long ago.

My technique at twelve consisted of sculpting the mask first in plastacene, then covering it over with several layers of wet newspaper...simple but effective.

Now that I was a grown professional, the challenge of the Wayne, full-page full-color assignment suddenly gave me large butterflies. My old simple schoolboy approach would never do. This called for sophisticated materials—professional, imported tools, complicated armatures—perhaps even a smock.

In the end, I went back to my self-taught Bronx technique of years before. But as I got into the finish a new development occurred. Because this was a portrait bust, I began by drawing caricatures of Wayne from many photographs. The drawings were very loose —just for feel—just to start the mood, the direction of the exaggeration. Immediately after that I began sculpting in plastalene. I had decided to work large because ol' Duke was supposed to look like he had Mount Rushmore all to himself. To lighten the weight, I formed the clay around two empty coffee jars, a cole slaw container and a small pickle bottle.

I had planned as I said, to "cast" the head in papier-maché, working in the round, removing the clay and ultimately painting the paper casting, but as I worked the clay with sculpting tools it took on the very stone-like Rushmore quality that I needed. I decided to give up the idea of the finished sculpture as papier-maché. With the addition of some real rocks and some "real" trees jammed into the clay, plus a little plastic figure from one of my son's kits to give scale,

it began shaping up. In the beginning, my concentration on the sculptural aspects of the head prevented me from achieving the "big Wayne" look of the original drawings. Only when I began to lay on the clay on areas like the chin and neck, beyond what I had anticipated, beyond my cautiousness, did I get what I wanted.

Had I persisted in my original plan of casting the bust in papier-maché, this is how I would have followed through. After the head was completed in clay, I would mix flour (I like Hecker's) and water to a loose cereal consistency. Newspaper dunked into this paste is best for the first layer because its thinness best retains the detail of the clay. Subsequent layering with heavier paper for strength lessens the fidelity of the clay more and more. The newspaper should be torn into strips, never cut. The torn edges hold the paste and knit with the other edges nicely. The strips should vary in length and width. Large smooth areas call for large strips. Working around the eyes, nose and mouth requires smaller and thinner strips. When the complete surface is covered with the first layer, it should be set aside to dry overnight. Rushing the drying of the first layer can result in disaster. After the first layer has dried, continue covering the surface with the wet paper. These next layers should be with heavier paper. I like the brown paper the Chinese laundry wraps my shirts in. I find brown wrapping paper and grocery bags too heavy to work. To accelerate the drying process, I use a small hair dryer. Two layers added to the original layer plus added strips at the bottom is usually enough for strength and weight.

After all layers are dry, the sculpture should be hard and powdery white. Next, remove the clay. For a mask, just pull it out from behind the mask. A sculpture in the round is more complicated. Cut through the sculpture lengthwise, so that you end up with two halves, remove the clay from both. Butt the edges of the halves together and tape over the cut with strips of paper dipped into the paste. At this time, you can also reinforce thin areas by pasting strips on the back surface of the casting.

Since flour and water is edible, I discourage little critters and other small animals from devouring the sculpture by spraying many coats of Crystal Clear inside and out. If your desire to paint it, use acrylic paints which will "take" on the sprayed surface. They dry quickly and brilliantly. Spray again. The sculpture will last forever.

**Gerry Gersten**

*Born / New York City*

*Studied / P.S. 75, High School of Music & Art,
Cooper Union, studied with:
Robert Gwathmey*

*Illustrated for / Boy's Life, Harpers,
New York Esquire, McCalls,
Ladies Home Journal, Good Food,
N.Y. Times, Holiday, Argosy, Redbook,
Vision, Money, True and Advertising agencies*

*Awards and Honors / Annual A.D. Shows,
Society of Illustrators Award, at graduation—
Foote Cone & Belding Award*

*Art Affiliation / Society of Illustrators*

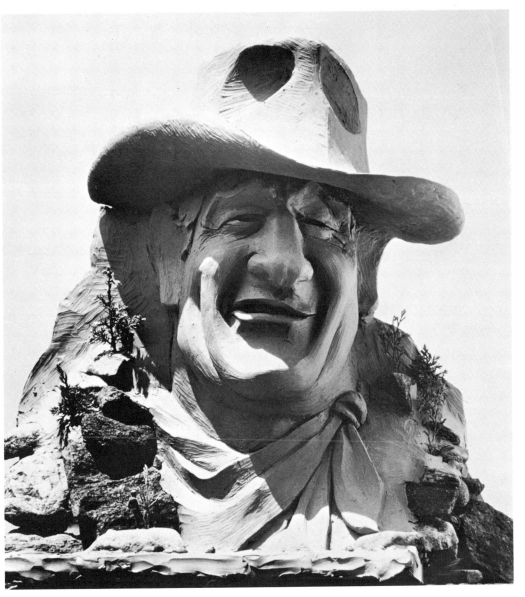

# Dave Epstein

The use of 3-dimensional images on a page is the way visual communicators and graphic designers break through the limitations of the flat, printed page. The thing about a 3-D piece is that for you to see it here right now, it had to exist…i.e. someone had to create it. So you stop and accept this fact, and then, perhaps, ask quietly "how the hell was it done?"

The answer in this specific case is "very carefully."

The wires all start in one place, do their acrobatic thing, and end up someplace else. The imagery had to be one of electronic precision and orderliness that befits this particular advertiser. And these qualities must also fit the general shape of a skull. A fistful of colorful cords jammed into a paper sculpture cranium just wouldn't make it. So every loop and every electronic element is calculated to remain in place … if not forever, then at least until it can sit for a portrait.

And the photograph is, of course, crucial. This can be a complication because you never really know how the hired photographer will "see" it. Wherever possible I take my own photograph so as to have more control over the final image. In fact I construct a piece always with its photogenic potential in mind. A good photograph can always enhance a piece of 3-D sculpture, but a bad photograph can ruin a beautiful piece. In this case, my compliments to the photographer.

**Dave Epstein**
*Born / New York City*
*Studied / College, Cooper Union*
*Illustrated for / Advertising and editorial clients*
*Awards and Honors / too many to mention*
*Art Affiliation / Art Directors Club, Cooper Union Alumni Assn., AIGA*
*Teaching / Pratt Institute 1964 to present*

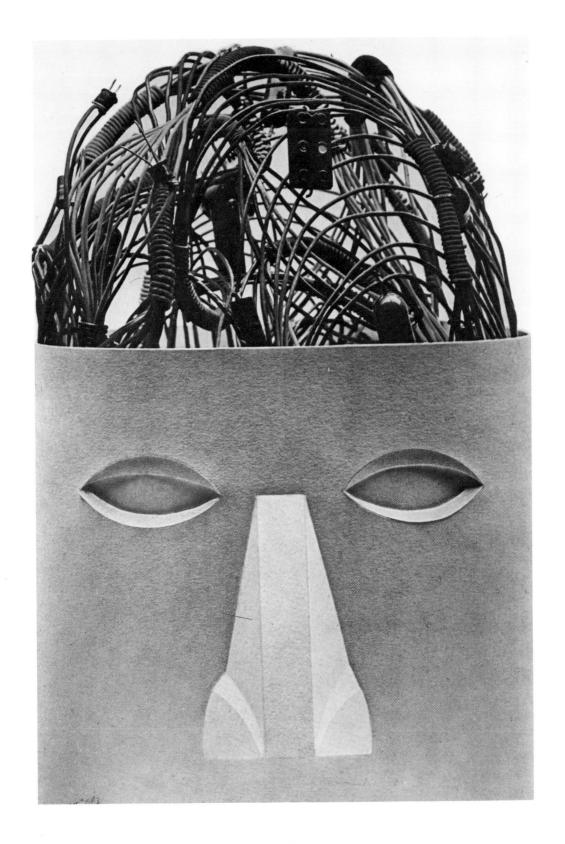

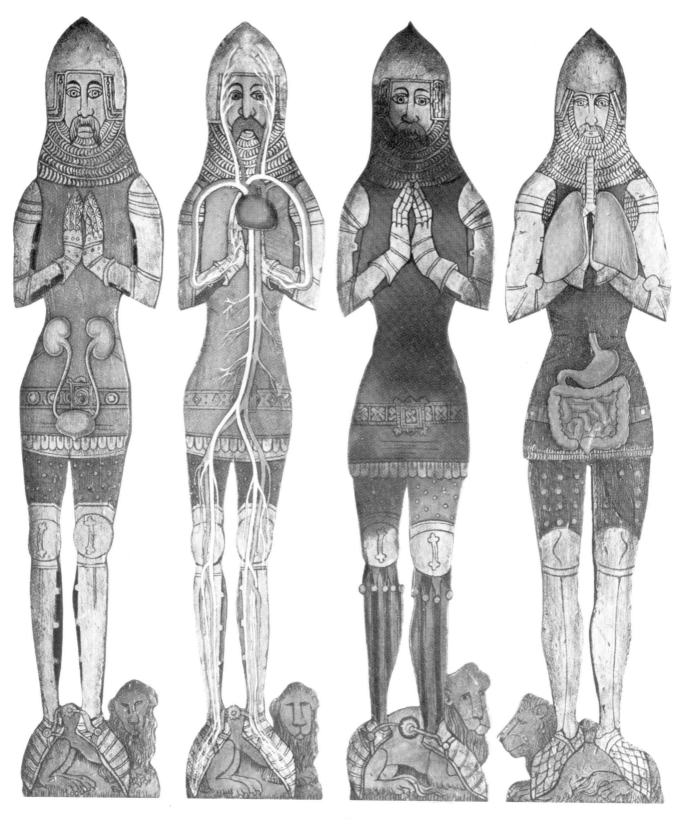

# Cal Sacks

Four wooden knights and how they were made. "How did I do it?"

"How did I do it?" The answer does not come easily. Time has erased the details and the finished art now resides in Bristol, Tenn. Never-the-less I shall stir the ashes of my memory and try to reconstruct the whole process.

The problem presented to me by Art Director, Les Barnett was an interesting one. Les knew that I did reproductions of old Tavern signs and had used my work for another job for the same Pharmaceutical Company. This time the client was introducing a new antibiotic, a product that was extremely effective in controlling many infections with the added advantage of having minimal side effects.

The Agency had come up with the idea of using 4 English Knights as symbols representing fighters and guardians. These figures were to be cut out and painted on wood then given a patina of age. Reference for the knights was found in reproductions of ancient English brasses. These brasses are found in English cathedrals imbedded in the floor as memorials for the gentlemen who are buried there. They are beautifully executed in a rather primitive style.

The next move was left to me as only the most rudimentary sketch existed. Since the finish was to be

*These painted figures were cut with a sabre saw from ½" pine. They're done in the style of early English brass burial decorations.*

*Polychromed wood with oval insert.*

Painted on old cabinet door.

This was designed for a magazine article.

executed in wood and therefore dimensional I decided to do a scale model on illustration board as a comprehensive. With the predetermined size of the finished art in mind I proceeded with the comp. Working from photostats taken from a book on Brasses I drew, then cut, the four figures from the illustration board with an X-acto blade. The cut-outs were then painted with acrylics exactly as they would be in the finish except that they were scaled down. When the paint was dry the knights were then mounted on foam core with ¼ blocks of wood to raise them off the background.

In about a week I received the go-ahead on the finished art. (Always a nice feeling.) There were changes but they were minor.

"Materiel" was the first move in preparing the finished art. I decided to use ½ inch clear pine instead of the usual ¾ inch pine because of the necessity of some intricate saw work. One thing against ½ inch pine is its tendency to warp. However, since the figures were to be rather narrow, warping was not a serious consideration.

Once again I resorted to the use of photostats blown up to the size that I had planned for the finish. Using a very soft graphite stick (6 B) I then blackened the backs of the stats, rubbed them with cotton for even distribution of the graphite, scotch taped them to the 4 pieces of wood and proceeded to trace the outside shapes of the Knights. The outline of the figures was all that was necessary since at this juncture all I was interested in was a line to cut on.

With the outlines now on the wood I then cut them out with a saber saw. (Band saw or jig would also have done the job.)

With the figures now cut out my next move was the application of Acrylic Gesso. I put the ground on roughly as this gives a nice texture for the antiquing wash.

When the gesso was dry the photostats were once again taped to the figures and the details were put on the figures with a stylus. A very hard pencil would do just as well. With the outlines now transferred to the gesso I was ready to paint. The color scheme had all been worked out on the comp. so the finish went rapidly.

When the painting was finished and dry all that was left to do was some judicious distressing. This effect is produced by punishment with a light chain, darts and a rasp. After the wood had received its application of distress a thin wash of raw umber is applied in small amounts and immediately wiped off while still wet. All I can say about this part of the technique is that experience is the best teacher. I use acrylic raw umber for the antiquing process and I also use oil color and feel that oil sometimes does a better job.

To complete the assignment, the men were positioned and mounted on a piece of ¾ inch plywood that had been painted white. In mounting the figures I used ½ inch blocks to lift the knights away from the background thus creating a shadow and giving the whole job dimension. Unfortunately this effect was completely lost in the reproduction since no shadows are in evidence.

All in all I feel the job was quite successful except for the aforementioned lack of dimension.

**Cal Sacks**

*Born / Brookline, Massachusetts*
*Studied / Art Students League*
*Illustrated for / National Magazines and*
*Medical Trade Books*
*Exhibited / Society of Illustrators, Air Force,*
*General Electric Gallery*
*Art Affiliation / Society of Illustrators*

75

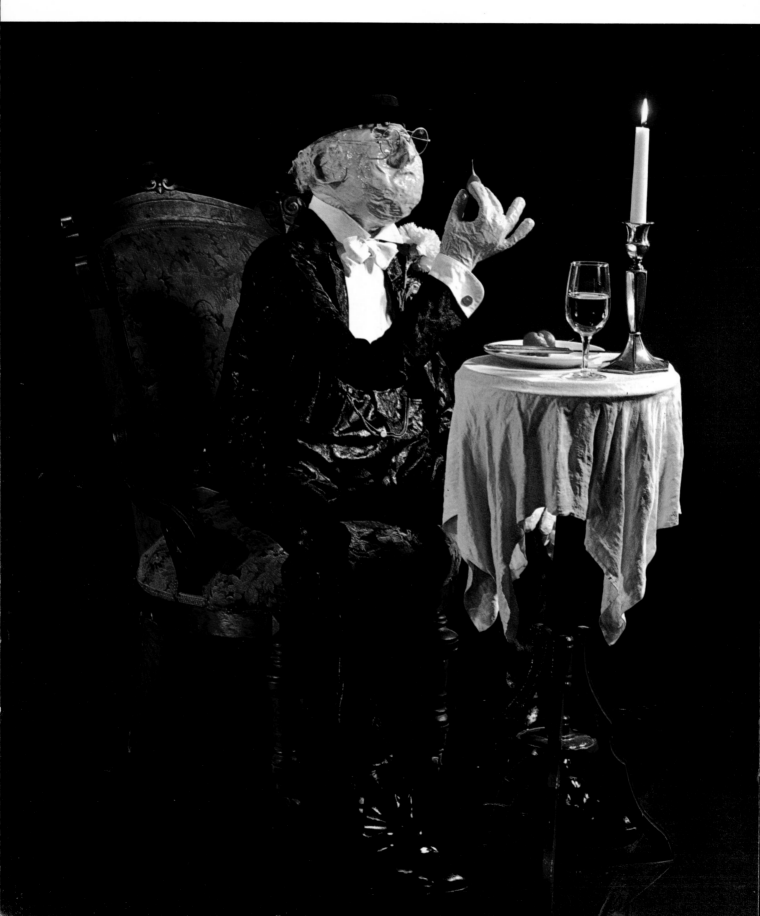

# Carol Anthony

My figures are statements about people; about our capacity for delight and wonder; about our sense of pain and beauty that surrounds our lives; about our sense of pity and compassion that makes us deal together, with our loneliness and fear; and about our sense of hope and dreams that is the fragility that transcends and binds us all together.

I try to capture a feeling, a sense of place within each figure that has influenced and moved me in my life; and to somehow explain and touch, in three-dimensional language and understanding, the simple warmth and vision in each of us.

My figures are constructed of newspapers, and torn sheets on a wire armature. I employ paste, Elmer's glue, plastic polyurethane and enamel in their forming and finish.

They are then dressed and adorned with articles of memorabilia and inspired bits and pieces of things once worn and loved by strangers. They come to me constantly by mail, from friends.

To me, each figure has a story told in the before and in the after: the before meaning my research and the process by which I feel and come to my final statement—and in the after meaning—that outside interaction and relationship between figure and people.

I need and want both sides of the story—each expression adding to the other to enhance and to enrich the meaning and the wisdom of the work, of the people and of me.

*Madam, circa 1900*
*(Collection of Mr. & Mrs. Jerry Pinkney)*

*Herb the Dude, The Radish Connoisseur*
*(Collection of Mr. & Mrs. Stacoms)*

**Carol Anthony**

*Born / New York City*

*Studied / Rhode Island School of Design*
*Studied with: Harve Stein,*
*Roger Pomprian, Tom Squorros*

*Illustrated for / Redbook, RCA Records,*
*N.Y. Times Magazine,*
*N.Y. Times Book Review, NBC Publicity*

*Exhibited / Ten one-woman shows; seven*
*group shows, Feature biographical*
*articles in Graphis, North Light numerous*
*newspaper articles*

*Art Affiliation / Society of Illustrators*

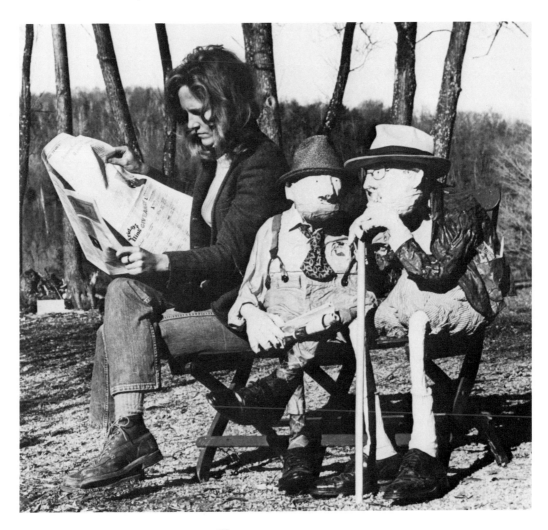

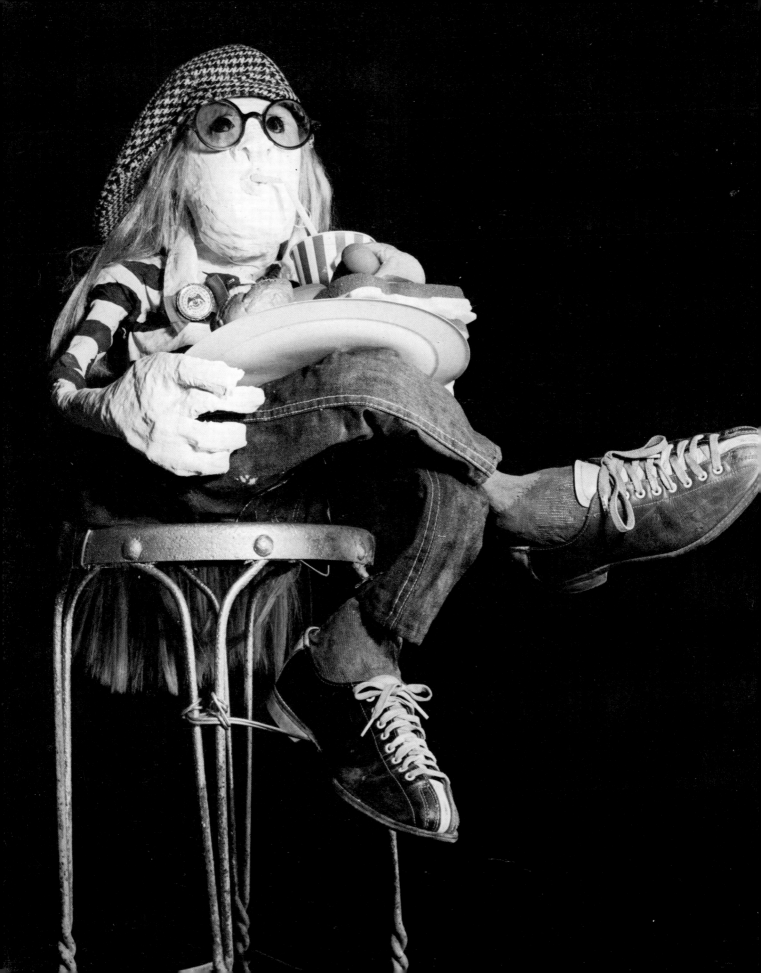

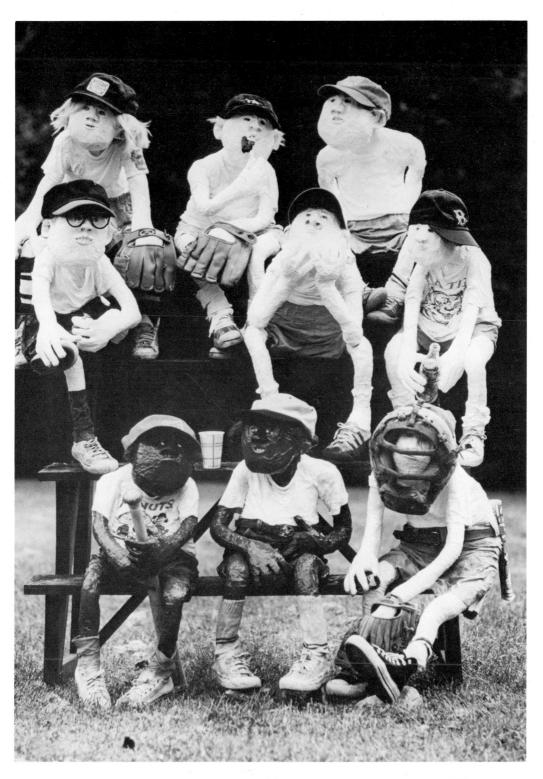

*Little Leaguers*

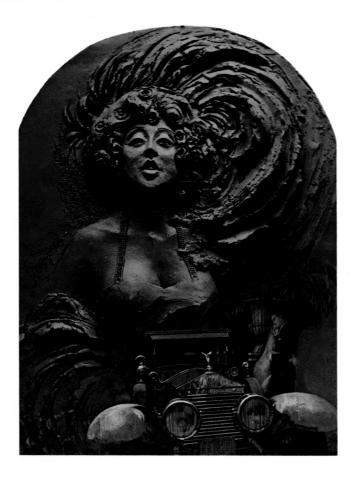

# Howard Rogers

This piece is a result of a change of pace from the drawing board a few years back. A change that led me into the fascinating medium of clay.

Experimenting, in as many ways as possible, is probably the most fun and rewarding part of illustration to me, and three dimensional work is one area which seems to be limitless in its possibilities. My only regret is that I have only scratched the surface and there are so many variations to be tried. But the business of drawing and painting in itself requires most of my time. Because of this, the work that I have done along the sculpture line has mostly been limited to making a picture, what ever the material. Clay, I have found, is a very flexible medium and is great fun to work with. In painting I like to bring the whole picture along simultaneously with clay, I can feel the forms taking shape dimensionally. With figures I can actually feel and see what happens beyond the contour lines. When working two dimensionally I am dealing with illusions to create the effect I am after.

Not being a trained sculptor, I probably work in many unorthodox ways. As far as tools and methods are concerned I use about anything I can find, such as bones, sticks and even an occasional clay modeling tool to achieve my final result. But mostly I use my fingers which are ultimately my best tools. There are many modeling materials available to the artist. I guess the reason I got started working with clay is that it was so readily available. My wife is a potter and has a fully equipped studio.

I find the making of a picture for illustration purposes, whether it is for advertising, editorial or book, very challenging and satisfying. For each project is a problem of its own. This particular project was one of illustrating a story which took place in the 20's and with sexy girls, exciting cars and romance to work with. How could I lose? The symbolic fashions of the flapper era allowed me to think in terms of something interpretive rather than just a rendition of another traditional painting. This solution resulted in the clay relief portion of the job. The next state, and a very critical one, was to light and photograph it. After toning the prints it was then dry mounted and the painted portion was done, which completed the illustration. It took a bit of trial and error at various stages but I came up with something here that was a different answer to the problem and most of all I had fun.

**Howard P. Rogers**

*Born / Medford, Oregon*

*Studied / Art Center School*

*Has Illustrated for / Bantam, Pocket Books, Bookley, NAL, Good Housekeeping, Cosmopolitan, Playboy, Woman's Day, Boy's Life, Sports Afield, Ford Motors, General Motors, Chrysler, A.M. Upjohn, Lilly, Johnson & Johnson, N.F.L., St. Louis Cards, Schaefer Beer, Early Times, Ballentine Scotch, Winston, Pall Mall*

*Exhibited / Detroit, Michigan and New York City*

*Awards and Honors / Detroit Bravo,*
*Art Directors Shows, Society of Illustrators Shows*

*Art Affiliations / Society of Illustrators, Westport Artists*

**Simms Taback**

*Born / New York City*

*Studied / Cooper Union*

*Has Illustrated for / Magazines, Children's Books, Advertising, Films*

*Awards and Honors / Art Directors Club, Society of Illustrators, AIGA, Best 10 Illustrators Children's Books, (N.Y. Times 1966)*

*Teaches / School of Visual Arts (1967-1970)*

I suddenly find myself in a book devoted to 3-dimensional work. I'm surprised. Ordinarily I do not do 3-dimensional illustrations. I am an illustrator who is primarily a designer. I have done wood and linoleum cuts and worked in all media including film. I have never really settled on any technique or style. I work toward what I feel is the right solution and what will satisfy me at the time.

The problem was to illustrate the *state of anxiety* for a drug house that would soon release a new tranquilizer. The solution was inspired by a combination of two things. One was a very beautiful photograph of a famous flemenco dancer I had clipped out of Life Magazine some years before. The other was a shoe box I kept on my closet floor filled with nails, screws, nuts, bolts, washers, hinges, hooks, and assorted used machine parts to fix things with.

The photo was a close-up of the dancer's face. His skin was old and wrinkled over which he had applied face powder, lipstick and eye shadow. He had the appearance of someone embalmed, yet his eyes were so strong and alive, they seemed to peer from behind a mask. It was this contrast of his eyes with the surface and texture of his face, which affected me most.

I redid his face on a piece of wood using the parts I had in the shoe box. I added parts from a broken alarm clock, a hair-curler and a bed-spring. I nailed and screwed everything down, painted the background and left the assembled parts untouched. There was no preliminary sketch or plan.

It was photographed and used for ads and direct mail. I think the original is hanging in the offices of Hoffmann-LaRoche, the drug turned out to be Librium.

# Simms Taback

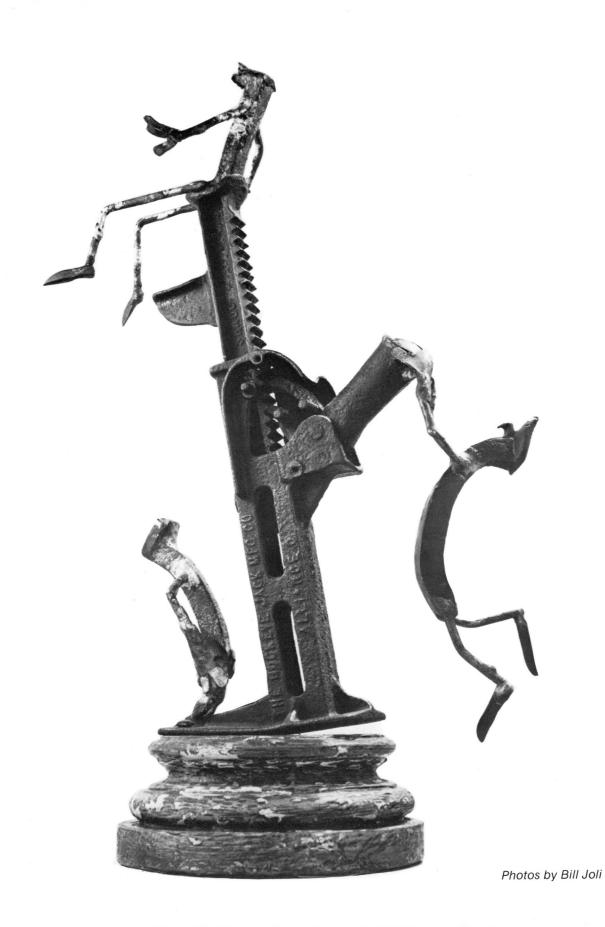

*Photos by Bill Joli*

# Howard Munce

Iron was first discovered about 1000 B.C. Unhappily, I didn't discover it until late 1959.

I wish I had come to it sooner. For I'd now be better at using it. And since it's hard work (one of its rewards) I'm apt to have a diminishing output in my eighties and beyond.

My real regret, however, is in realizing that when I was an art student with long vacations I could have apprenticed with the local blacksmith and learned the rudiments properly. I've come to my limited savvy by trial and lots of error. A metallurgist would retch at my ignorance.

An unlikely fluke turned me towards three dimensional work. Before it happened I had no preliminary yearnings beyond a natural liking for tools, sweaty work and a deep love for rusted junk. (In the next life I wish to be born a rat so I don't even have to leave the dump to go home for meals.)

Long ago when I was an agency art director I had a photograph to do with Phil Silvers. He was a comic sea captain shown putting a frigate into a beer bottle. Among the props I had requested was a set of X-Acto knives. When the shot was done and the spoils were being divided, I took the knives. Some time soon after I tried doing something in wood. It turned out to be a crude whittling.

But the three dimensional bug had bit! I plunged into a winter of wood carving. I quickly added rasps and heavy-duty chisels to my tools.

The most exciting discovery was to be released from the *illusion* of making something round and to suddenly have it *be* round. Beyond that was the challenge of making the piece work from *all* angles—not just the front view.

New things began to happen in my head—I felt new stirrings in my gizzard.

About this time my young son unearthed a railroad spike while we were both picking through some rubble. When I got it home I put it in the vise and tried a file on it. That did it! This was *my* stuff. Iron! The first piece I did had to be taken to the local garage to have the parts welded together. The next week I bought my own tanks and equipment. Since then, I've added a portable forge and a ton of tools. The only time I touch wood any more is to make bases.

Over the years I've come to some conclusions about what I seek to do and what is done by others in this very badly treated idiom.

First I must explain that anyone can learn to weld or braze with a half-hour's instruction and very little practice. Also, anyone can easily find iron and steel hardware and junk that vaguely looks like something else—bolts, screws and springs for limbs—rivets for eyes, etc. It's this cheezy kind of hobbyist thinking that leads to the gift-shop horrors both domestic and imported that currently flood the country. Poor old Don Quixote takes the biggest beating. He's always been a loser—but never so much as now when he and his sorry nag are made by the thousands from hammerheads, nuts, nails and washers. They're held together

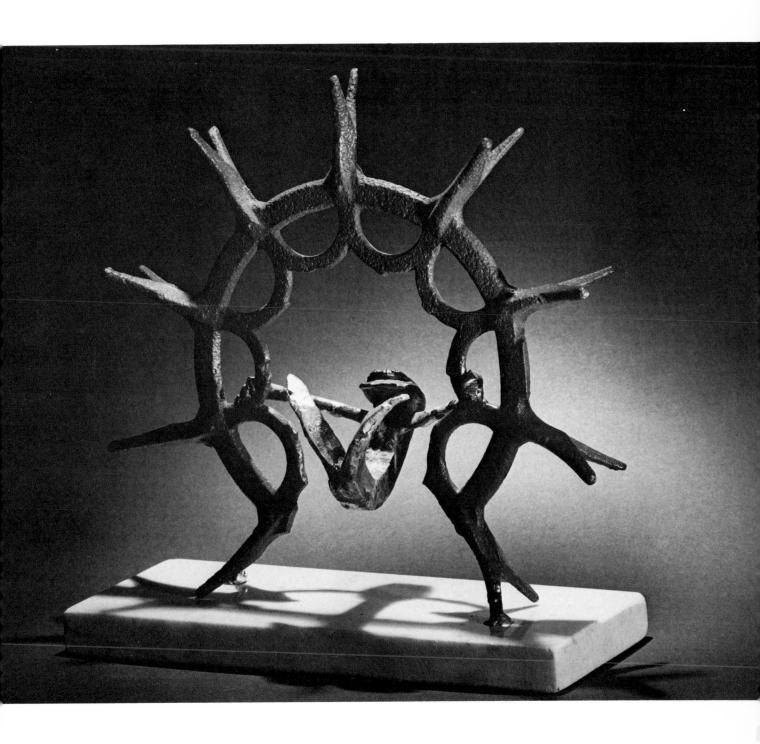

by a touch of spot-weld then covered with the final shame—a shroud of flat black. Better they should spray the foreman of the assembly line.

In the beginning I was guilty of the "looks-like-something-else" school of found objects. It's an easy way to have your neighbors think you're a clever fellow. After all, the world still thinks highly of Picasso's ape with the head made from a toy car—and his goat with horns that were once handle-bars. But of course they are only *details* in altogether worthy, witty works. Art attempted from vacuum cleaner parts are not apt to be either.

I have come to find that pieces *fashioned* from stock or at least bent or hammered or burned from existing junk is not only more difficult, hence more satisfying, but it forces you into discoveries and decisions that are truly and seriously sculptural.

When you come to think on that level you are apt to produce better things—and more important, you have readied yourself to view *real* sculpture with intelligence. And that in turn opens a world of such wonders that one can only be everlastingly grateful for the good fortune of having stumbled into it.

If fate hasn't tripped you yet, encourage it to do so.

**Howard Munce**

*Born / Jersey City, N.J.*

*Studied / Pratt Institute and
with: Julian Levi, Stuart Davis*

*Illustrated for / Gourmet, Boys Life, Lithopinion,
N.Y. Times, Young Miss, Advertising*

*Exhibited / Society of Illustrators,
New York University,
New Britain Museum of American Art*

*Art Affiliation / Society of Illustrators,
past president.*

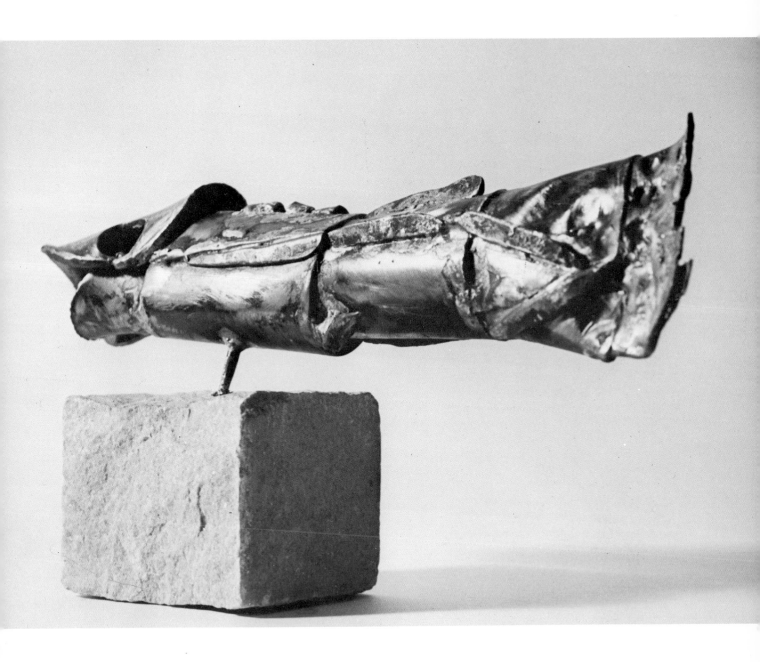

# Don Almquist

Head of a Woman—Illustrators 14.

This all brings me back to the days of balsa wood, tissue paper, common pins and dope—which we never sniffed unless the airplane happened to fly up your nose. There are certain distinct advantages to working in 3-D aside from the obvious creative possibilities. There is a plasticity that allows you to change your mind as the job progresses. I like to think that your concept "grows" as the work is finalized.

The head of a woman that appeared in ILLUSTRATORS 14 was a particularly exciting problem in that it was to be an ad for a drug to control tension and psychic stress for the average housewife market; a pretty banal subject when you consider all the ads you've seen of the harried housewife clutching her head while the kids have just demolished the house. The problem was, as usual, to come up with a creative solution to a rather ordinary situation. I was fortunate to work with one of the country's leading designers, Dick Jones, who would only be satisfied with the best creative approach.

I suppose the phrenology head was the original idea and in this case, why not a large woman's head divided like a printer's type case that would allow you to include all the grim aspects of this disorder and would keep the client stress-free. From this point it was necessary to make a list of all the various things, real or imagined, that leads to psychic or physical stress. Foods, such as onions and salami; environ-mental things, the telephone, the children, the sink full of dishes and overflowing, and a few abstract ideas, as time, a rope that is frayed and taut and finally an old photo that might denote an inherited disorder. Those things that didn't work graphically were dropped.

The head was constructed of balsa with the facial area not really tied down until all the components were considered, allowing for compartments that would accommodate the elements and their relative importance to each other. The time came to start fashioning miniature salamis and onions out of papier-mache and raiding my daughter's doll house (and if that didn't work there was always the local toy store).

Everything was placed together, composed in 3-D, but for some reason it didn't read as a woman's head. There had to be some "anchor of reality." What was missing was an eye, and an eye that would be in its correct position. The drawing of the eye was a super-realistic rendering that was the anchor of reality to the overall head but also a contrast to the decorative cut-out children as well as the various 3-D elements.

As the job went along, there were many small technical problems, such as how to show a sink overflowing, a realistic rendering wouldn't work, but a few gobs of polyester resin would do the trick; and balsa wood, easy to work with, but with a rather vanilla visual pallor that could only be remedied with wood stain.

All in all a dream job!

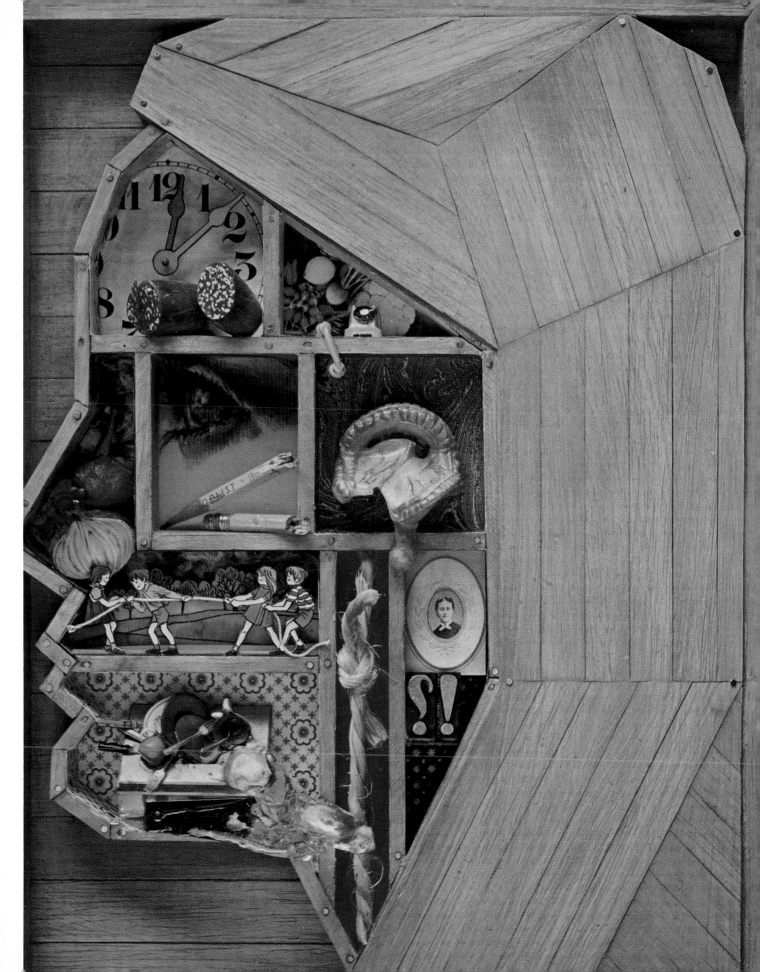

Robin and Frog/American Book

*This piece was for a grammar school science textbook that would be used as a double-page spread to illustrate the life cycle of a frog and a robin. It became a mixture of real objects and drawn animals that became so intricate that it required more than the usual supply of patience putting it together, not unlike the ship in the bottle.*

**Don Almquist**

*Born / Hartford, Connecticut*

*Studied / Rhode Island School of Design*
*studied with: Harve Stein, Jose Guerrero*

*Illustrated for / Advertising, editorial, book*

*Exhibited / Ad Clubs, Society of Illustrators*

*Awards and Honors / Awards of Excellence,*
*Certificates of Merit AD Silver Medal*

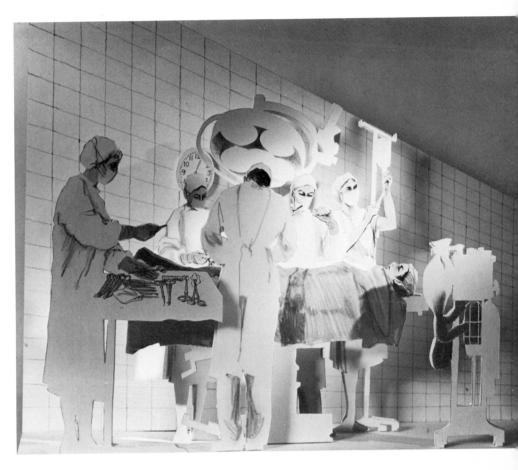

## Wedding Cake

*This was truly a fun job to be used as a self-promotional piece. It is composed entirely of papier-mache except the cut-out hippie bride and groom on the top of the wedding cake and the silver confectionary beads that were glued on later.*

## Operating Room Scene—Illustrators 16

*The problem was to find a new approach to illustrate the standard and over-used operating room scene. This is an example of how very important the lighting and the photography is to the 3-D job. I usually insist on being present when the job is being shot so I can convey to the photographer the correct mood and perhaps assist with the lighting. (Attached are a few progressive photos with different lighting.) I was really amazed just how dramatic and __real__ this flat paper-doll technique became with the proper lighting. In reality this was an idea and a 3-D sketch. The drawings were done on layout bond and double cemented to foam core board and later cut out with an X-acto; and what an operation that became! The client liked the sketch so much that it was used for finished art; a situation that is a true rarity!*

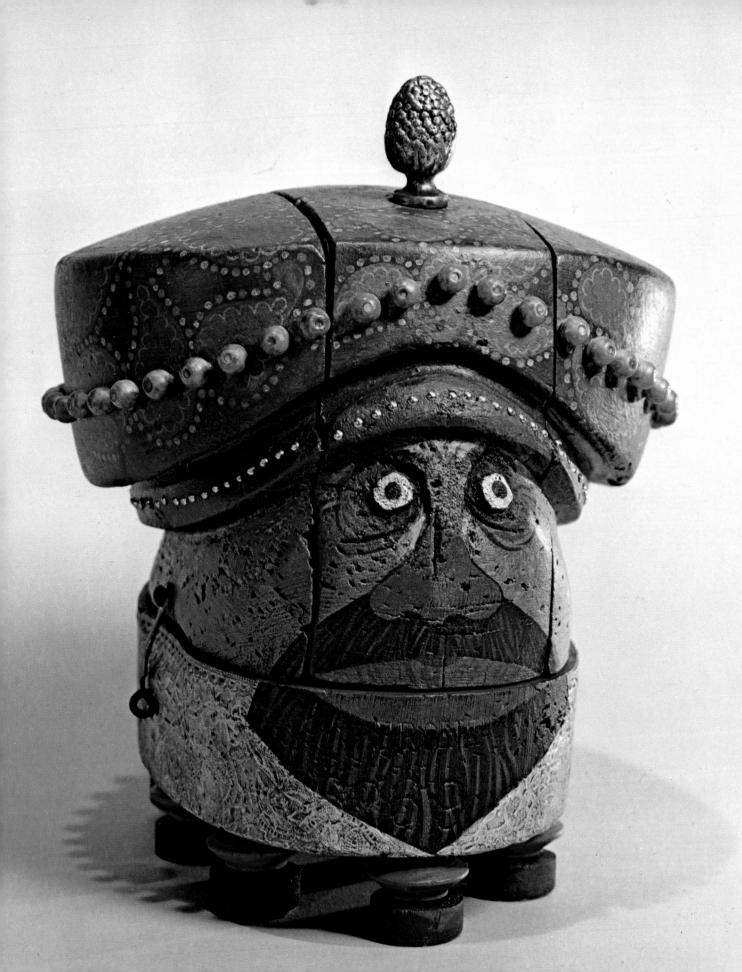

# Donald Hedin

As a constant experimenter, my first forays into three dimensional work were for my own pleasure. It all began with a found piece of wood which had a strong resemblance to a toy soldier: it needed only the application of paint to complete. That first piece happened quickly and easily and seemed quite successful. The pieces that have followed have become increasingly more ambitious and complex as my interest and enthusiasm grew. I still make it a point to keep as much of the original found shape as possible modifying only a minimal amount. The rest depends on painting and the combining of the original piece of wood with anything else that comes to hand to help further the original concept.

In Omar Khayam—the piece reproduced here—the creative ball started rolling with an old form used in the manufacturing of women's hats. I found it in the New York millinery district. They were getting rid of them for from one dollar to five. I bought up all I could carry. This one was dusty and distressed from much

*Found in a millinery shop. This hat form shows evidence of its former life. Note nail holes. Hooks which held its pieces together will be kept in final work as interesting details and texture.*

*Partially taken apart, the form resembles a Chinese puzzle. First step in making Omar was putting in tongue and painting the inside of the mouth.*

use and abuse. It had the look of a turbanned head. It was built in sections, to facilitate the hat-makers job. I tried to capitalize on this aspect; the hooks holding it together became earrings, the center section, when lifted by the decorative (and functional) finial, appears to be an open mouth. I started painting right there, first pasting down a verse from the *Rubiyat*, to serve as his "voice," i.e. message. Next, I painted the teeth, mouth and throat—including an uvula! Then I turned my attention to the exterior. The lacy collar is a paper doily, cut into irregular medium sized pieces. I used acrylic medium as a glue and went around the neck covering it in an irregular way with the pieces of doily overlapping each other. The face and turban came next. I nailed a row of wooden beads around the turban. The little feet came last. They are combinations of wooden turned odds and ends from my stock of raw materials.

The last step is always the most fun...the glazing of colors all over, to produce that patina of years of dust and grime which gives these pieces a look of antiquity. This glaze is a mixture of water, acrylic paint and the acrylic medium. I use a thin mixture; browns, umber, blue, one over the other. Toning down a too bright color, letting the color of the glaze sink into low places (such as the holes in the paper doily) bringing out the texture as no other way could.

A last word on this type of work. A necessary ingredient is a supply of raw materials; it helps to develop pack-rat qualities, acquiring all manner of odds and ends that could be conceivably used at some future date. It often just might be what is needed to make a piece come alive!

*Odds and ends. Almost any small bits of wood can be saved towards the day when they can be used to embellish some piece.*

**Donald M. Hedin**

*Born / Bridgeport, Connecticut*

*Studied / Bassick High School, Bridgeport,
Pratt Institute*

*Illustrated for / Most textbook houses, Several
national magazines, paperback houses, special
interest magazines and advertising promotion*

*Exhibited / American Watercolor Society,
Society of Illustrators, New England, Salmagundi,
Several New York galleries for single shows*

*Awards and Honors / Wm. Church Osborn (Amer.
Watercolor Soc.) N.E. first prize,
Society of Illustrators Award of Excellence*

*Art Affiliations / American Watercolor Society,
Society of Illustrators*

97

# Don Ivan Punchatz

This illustration of the Coal Baron for Playboy magazine is another departure from the style that is ordinarily requested by clients. My background as an ad agency art director has oriented my attitude as an illustrator toward seeking out new styles and techniques as solutions to the assignments I'm confronted with daily. These solutions are derived from the inherent limitations of any given problem. I don't arbitrarily impose a personal style or technique on an assignment.

I feel that my most successful work has derived its aesthetic impetus from some unique factor found in that *particular* assignment and nothing else. In this case, I decided upon the accompanying solution for the portrait of this venerable gentleman who created an economic empire from his West Virginia coal mines. The entire body of his colossus-like figure was built up with small, coal-like stones bought in an aquarium supply store. The buildings in foreground were then painted on a thin board projecting forward from the background.

To bring in one final point of serious consideration, one that I feel is often neglected, three-dimensional artwork for print advertising or editorial use must be designed with the final printed image in mind. A disregard of this final application may produce a fine sculptural solution, but more often than not, a poor illustration when considered as a two-dimensional composition.

Combination of painted
illustration and
three-dimensional objects.

**Don Ivan Punchatz**

*Born / Hillside, New Jersey*

*Studied / High School, School of Visual Arts,
Cooper Union, Studied with: Burne Hogarth, Bob Gill,
Francis Criss, Nicolas Carone*

*Illustrated for / Playboy, Esquire, Redbook,
Ladies Home Journal, True, Horizon, Venture, Oui,
National Lampoon, Seventeen, Travel & Leisure,
American, Think (IBM), Look, Time-Life Books
—Every major advertising company and many
smaller design boutiques*

*Exhibited / Fine art galleries in New York, Texas,
Pennsylvania, Ohio, Mexico, Society of Illustrators
shows, AIGA show, New York Art Directors Shows,
Graphis, CA Magazine, etc.*

*Awards and Honors / Many distinctive merit awards
of excellence from the above shows*

*Teaches / Texas Christian University for past 3 years*

100

# Gene Szafran

Sometimes the need arises to put more than color or line on a flat surface. This personal need to raise, lower, or modulate the surface must be translated to fit the job, or the job altered to fit this kind of expression. My first thought seems to be—what will best express and illustrate the given problem. Could it be a painting, a collage, a construction, sculpture, a piece of macrame, a body cast, or perhaps a tinted and stained photograph? Generally, I work on some-thing that catches my interest, trying to work it into my portfolio and hoping a client may find it applicable to his problem. In the case of the Elektra cover, the problem consisted of giving a Baroque feel to the piece, or something one might imagine seeing carved on the side of a Renaissance theatre wagon belong-ing to a troop of traveling minstrels. Then came the hunting of antique shops for objects and decorative bric-a-brac from which molds could be made. The

heads came from a carved wooden door panel. The trumpets were plastic toys, purchased in a dime store. The letters were cut from balsa wood and the angels were cut and carved from pine. The composite mold of these objects was then cast in hydrostone and polychromed. The procedure for most bas-reliefs as applied to jobs never seems to be quite the same. In addition to found objects, antiques, etc., some objects may be carved in wood, modeled in clay and

recast, or the mold is molded in negative. Some projects include casting the human body. The technique seems to follow the idea, that is, the look is decided on first, then comes the task of devising the best way to execute it. Sketches for these kinds of jobs are next to impossible since you really cannot tell what the finished product will look like until you actually do it. It's a little like printmaking, where although you've worked on the plate and calculated the results you always get a kind of surprise when you pull that first proof. As a result I usually end up with two or three versions and pick what I think is the best one, instead of submitting sketches and following a step-by-step procedure. Liberation from the standard procedures and concepts is a very vital and refreshing reward of dimensional art as applied to illustration. And what is illustration anyway? I earn my livelihood as an illustrator and I don't really know what it is. I suppose it is that which illustrates, anything that illustrates.

**Gene Szafran**

*Born / Detroit, Michigan*

*Studied / Society of Arts & Crafts, Detroit*

*Illustrated for / Major automobile accounts, album and book covers, annual reports, children's books*

*Awards / Numerous art and photograph awards— latest, Award of Excellence, 17th Annual Exhibit of Society of Illustrators*

*Art Affiliation / Society of Illustrators*

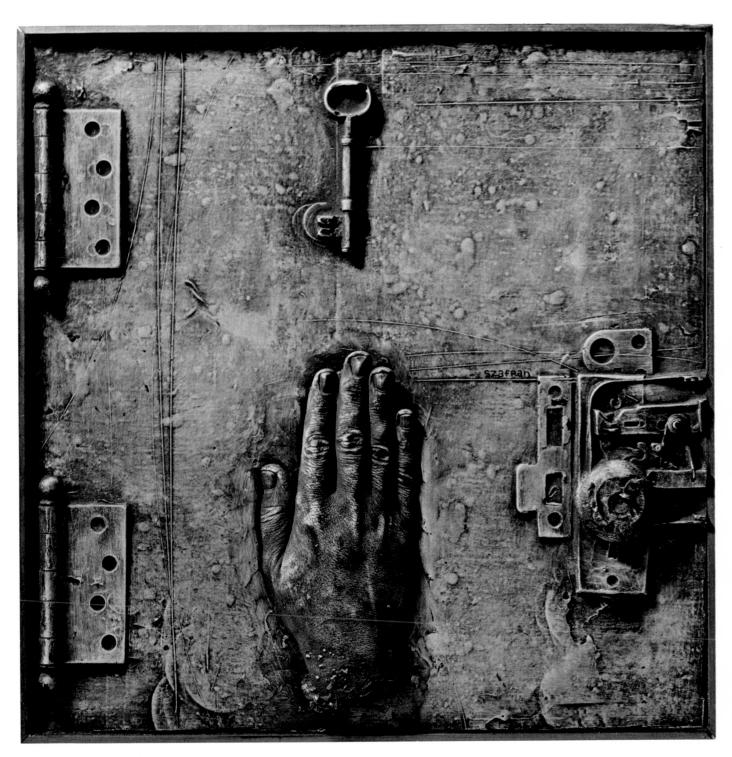

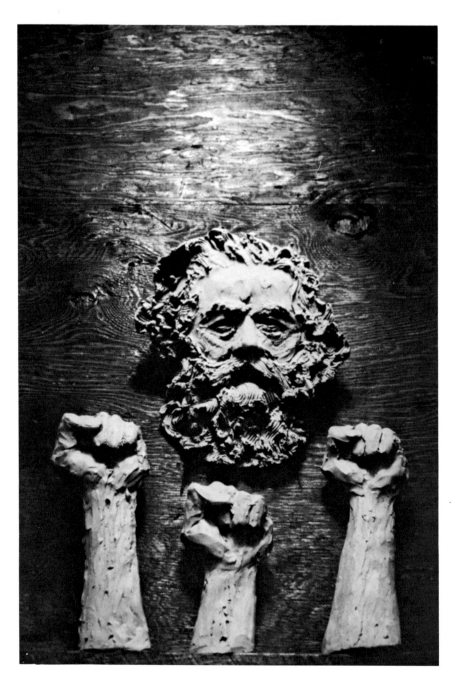

104

# Herb Tauss

Doing Karl Marx was an exciting project. His philosophy has influenced more than two thirds of humanity. I have always considered him to be one of the more important men civilization has produced.

In researching Marx and that period I discovered that the workers' symbol of the time was a raised clenched fist. I also discovered that existing photos of Marx are very few, and everyone has seen reproductions of them or paintings and illustrations using the same material.

In submitting sketches, the head of Marx with raised fists was the most acceptable because it made the least political statement in a more universal context. Sculpting it, I felt, would bring a more dramatic quality to it, and it would not be a look-alike to all the things on Marx I have seen.

I used plastaline in the making of the piece. Of all the plastalines, "Roma" is the best quality I have worked with, and as far as I am concerned is the only one to use. The bad property of plastaline is that it never hardens. You don't have a permanent piece. It is primarily used for studies or as something to make a mold of for casting. I chose it because of the deadline imposed, and did not want to go through the shrinking, drying and cracking, warping, etc. of other sculptural mediums. It also gave me a sure way of working with complete control of being able to dig into it or adding. Working in the round is always refreshing. It literally is something you do with your hands. Finding the magic of the clay.

When using plastaline I cut the block into half-inch slabs so that the clay could be warmed in my left hand while applying it with my right. In the early stages I am finding the drawing and building planes, and interplaying the textures and masses. After the resemblance is there and things look good, I start using the standard sculpture tools or anything that's handy—toothpicks, ends of brushes, etc. and refining the piece.

A plywood board was used as the background and burnt with a propane torch. The burnt board added another texture—a good foil for the clay, and excellent drama for revolutionary writing. Photographing it myself (you can tell because it is out of focus) I decided the shaft of light from above would be the most dramatic. The piece eventually weakened and fell apart. Karl Marx crumbled. Maybe that has great symbolism, or maybe one shouldn't use plastaline.

**Herb Tauss**

*Born / New York City*
*Studied / Self Taught*
*Illustrated for / McCall's, Redbook, Ladies Home*
*Journal, N.Y. Times, Saturday Evening Post, Good*
*Housekeeping, Argosy, Guideposts, Fawcett, New*
*American Library, Curtis Paperback Library, Avon, etc.*
*Awards and Honors / Art Directors Club Gold*
*Medal, Society of Illustrators Citations*
*Art Affiliations / Society of Illustrators*
*Teaches / Marymount College, '72-'73, Pratt*
*Institute '73, Parsons School of Design '74*

# Gerald McConnell

My Grandfather's Things.

This assignment for Bruce Hall at Paperback Library was to do a new cover for a previously published book which they wanted to reissue. They wanted it to be dimensional. This was the story of an early settler in Vermont who made or grew most everything he needed to run his farm and home. He told in detail how he did these things.

After digesting the story for a few days I did some pencil sketches and finally settled on three. I always try to look ahead to be sure I'll know how to construct the finish and not get trapped into corners I can't escape from. In the end, the editors chose the toughest one. It never fails.

In all three sketches the largest item would be an actual object which I already possesed. They felt the trunk and the ox yoke offered less than the box. This was a blow because all the props would have to be hand-made. I decided the assemblage would be held in an old bread tray which, I had happily acquired some time before. Since the idea was to have the assemblage take up the whole cover, the tray had to be cut down to scale exactly to the cover size. I always find scaling a difficult task. And since this had to be right on the button I figured it out on paper first then made a pattern as a double check. It had to be cut down on two sides.

The problem with changing it was that the corners were rabbited. I felt it was necessary to preserve that even though it wouldn't show in the finish. I did this by cutting through the rabbited pieces and then adding those pieces back to the finished tray after I had reconstructed it.

The shelves were made from slats from an old lobster trap which had weathered from many years in the salt air. Wood like this has a feel and patina that can only be gotten from time and weather. It took two lengths of slats to make one shelf so they also were pegged together and the cuts were hidden. The slats were warped and out of square so most had to be planed and have square ends cut. They were installed in the box by pegging from the two sides and back. I prefer the pegging system to nails with older wood

*Rooster made of toothpicks for a book on Aesop's Fables.*

**THE ROOSTER AND THE EAGLE**

To young Roosters were fighting fiercely over a worm. Finally one Rooster was badly beaten and covered with wounds, so he ran away and hid in the hen-house. The conqueror, proud of his victory, flew to the top of the hen-house to tell the world about it. But an Eagle had been sailing around above the hen-house, waiting for a chance to catch himself some dinner; and no sooner did the Rooster start to crow than the waiting Eagle swooped down, and carried him away.... **Don't crow in fast company.**

as it avoids splitting and sometimes the force needed to drive in a nail can be disasterous. I set up the type area by covering a board with off-white burlap and then glued on a rope border.

Then I made the individual objects and gathered the memorabilia. These included some old labels, photos, clippings from an old catalog and a slab of real Vermont slate. Everything was then fixed with Elmer's glue.

I used balsa wood for the objects as I usually do when there's no load to carry. Its easy working advantages are obvious. They were all cut out with a coping saw and rough sanded until the basic shapes were right. I then worked on each piece until it was finished.

When the hand work is done to your satisfaction you have one more very important control and that is the photographer. This is where you "paint" it with light and shadow and where you enrich it or just settle for a bright snapshot.

It's the stage I can't wait to get to.

108